IMAGES OF *Kansas City*

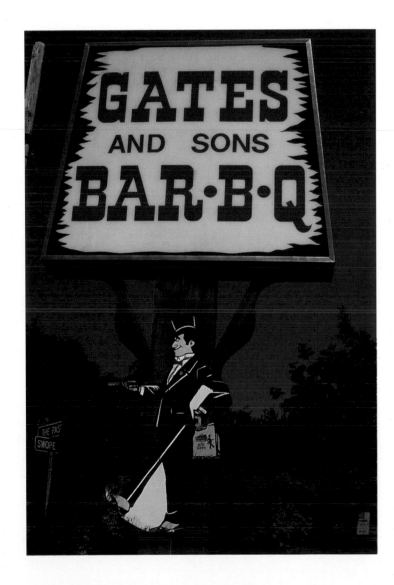

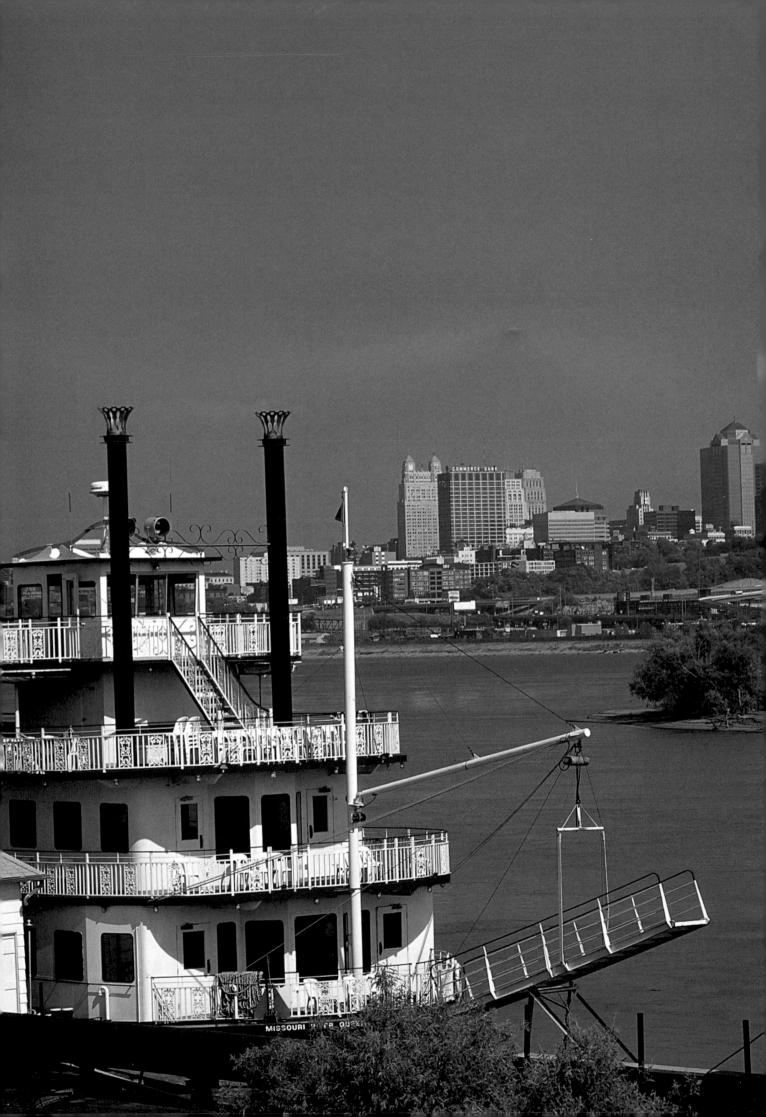

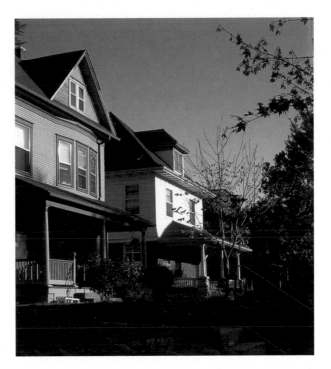

IMAGES OF
Kansas City

Photo Selection and Introduction by William Mills

UNIVERSITY OF MISSOURI PRESS COLUMBIA AND LONDON

Text and selection copyright © 1996 by
The Curators of the University of Missouri
All rights to photographs are retained by the photographers
University of Missouri Press, Columbia, Missouri 65201
Printed and bound in South Korea
All rights reserved
5 4 3 2 1 00 99 98 97 96

Library of Congress Cataloging-in-Publication Data

Images of Kansas City / photo selection and introduction by
 William Mills.
 p. cm.
 ISBN 0-8262-1070-8 (alk. paper)
 1. Kansas City (Mo.)—Pictorial works. I. Mills,
William, 1935–.
 F474.K243I45 1996
 977.8'411'00222—dc20

 96-1236
 CIP

∞™ This paper meets the requirements of the
American National Standard for Permanence of Paper
for Printed Library Materials, Z39.48, 1984.

DESIGNER: KRISTIE LEE
PRINTER AND BINDER: SUNG IN PRINTING AMERICA, INC.
TYPEFACE: MINION

FRONT MATTER ILLUSTRATIONS: p. i, Gates and Sons Bar-B-Q,
by Tim Williams; p. ii, *Missouri River Queen,* by William
Helvey; p. iii, midtown neighborhood, by Jessica Withington;
pp. iv–v, The Children's Fountain at Burlington and Oak, by
Pat Jesaitis; p. vi, Power & Light Building and H. Roe Bartle
Exhibition Hall, by Terrance McGraw.

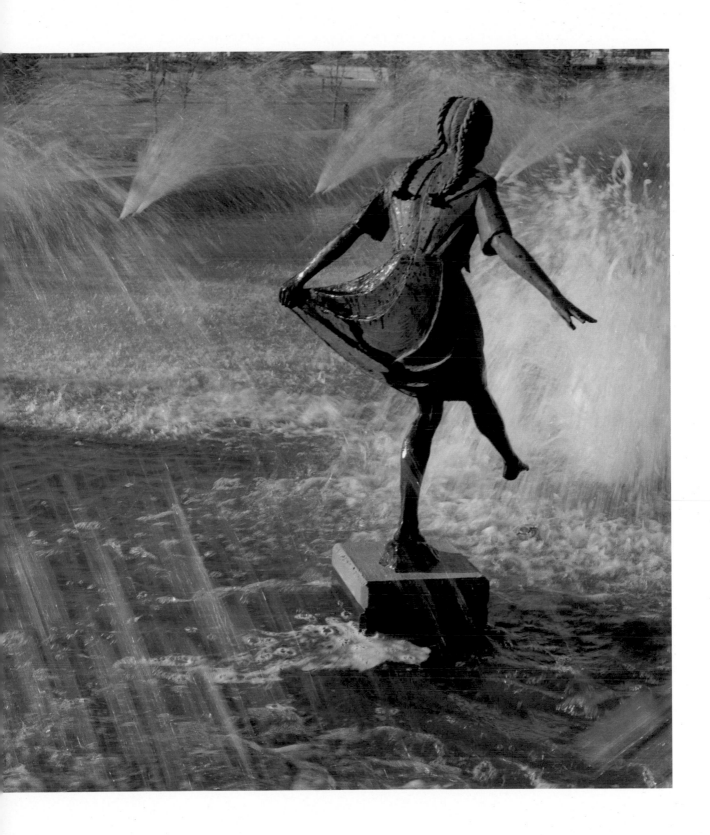

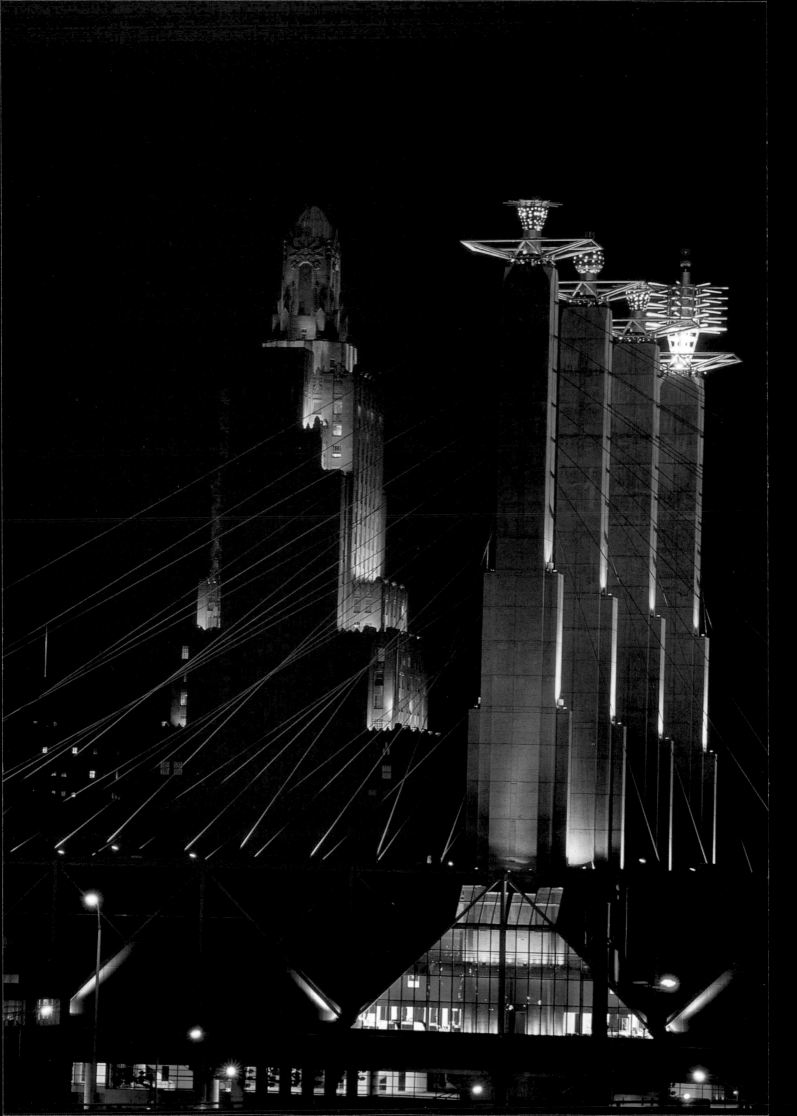

INTRODUCTION

by William Mills

This collection of color photographs of Kansas City was drawn from the many images submitted for a contest sponsored by the University of Missouri Press. As the one chosen to select the winning images, I looked with anticipation for what aspects of the city had interested the various photographers. The contest had few restrictions about subject matter. Since this is a selection of *color* photographs, it is not surprising that there were many submissions of the Power & Light Building and H. Roe Bartle Exhibition Hall. The same is true for Country Club Plaza. Colored lights lend themselves to spectacular images, and during the Christmas season thousands go to view these displays. Thus the medium, in part, shaped the choices.

Numerous images on these pages are concrete evidence that Kansas City looked west from its beginnings in the mid-nineteenth century. Its geography and topography had a lot to do with this. The Missouri River radically shifts its southern direction to the east, and it was at this bend in the river that travelers and freight haulers arrived, coming from the east and the west. Early on, steamboats carried the traffic; later it was the railroads. After all, the Santa Fe and Oregon Trails have their origins here and in nearby Missouri towns.

Kansas City became the place to outfit the wagon trains going west and the place where businessmen bought the furs, cattle, and other goods coming from the west. As the great cattle drives made it north from Texas, the city became a center for the meatpacking industry. It was always a city of entrepreneurs and a jumping-off place for people with dreams about land and riches to the west. It's not for nothing that one thinks of Calamity Jane (born in Princeton, Missouri) rather than Hester Prynne, and of barbecue rather than lobster. What a hardy lot it was that took on the rigors of the trek across the great plains and the threat of Indian attack.

This hardiness is reflected in the sculpture of *The Pioneer Mother* in Penn Valley Park. In the same park we have the sculpture of *The Scout*, an equestrian statue of a Sioux warrior gazing at the skyscrapers on the skyline of downtown Kansas City. Over in Barney Allis Plaza we have the dynamic *Bronco Buster* statue, and near the R. Crosby Kemper Arena and the American Royal, metal bull sculptures. Even some of the events in the American Royal arena remind us of Kansas City history: the rodeo and stock show, the draft horse contest. The very name of the football team, Kansas City Chiefs, reflects the city's Indian past of tough, aggressive warriors.

The wide open spaces to the west have influenced in less tangible ways certain historical attitudes. I am thinking of a belief in boundless possibilities that seemed to characterize a cast of mind. Over the horizon of the "prairie ocean" lay great promise, and this created a future-

oriented city not accustomed to limits (some have even said a city with an ambitiously materialistic vision).

After a fashion, the very name of one of Kansas City's most striking buildings, the Power & Light Building, unintentionally serves as a metaphor for the city. Power has been accumulated in the city through its vast mercantile and manufacturing interests, and many of the city's leading citizens believe that this concentration of power and wealth is the means for realizing a beautiful city, or a "clean, well-lighted place," to borrow the title of former *Star* reporter Ernest Hemingway's short story. The fact is that not a few individuals have used their wealth and influence to significantly shape the city's skyline, its statuary, the very subjects of many of these photographs; and sometimes, though not always, we recognize this from the names of the buildings, the fountains, the memorials. One or two examples will perhaps serve to make the point.

Several photographs are of the Nelson-Atkins Museum of Art. From the time William Rockhill Nelson arrived in Kansas City from Indiana in 1880, through his newspaper the *Star* and other business interests, he set about not only making a fortune but also making his city a cleaner, more beautiful place. For example, he used his influence to have the city hire George M. Kessler to plan for many of the boulevards and parks in the city today. He was a thoughtful planner of his Rockhill developments. It is the Museum of Art, however, that reminds most people today of his philanthropy, along with that of Mary Atkins. Nelson had decided early on that Kansas City citizens needed to be able to see beautiful works of art. At first he provided copies of great European masterpieces for people to view, but his will and trust provided for buying original works of art. Before many years passed, the money from the trust was also used, along with Mrs. Atkins's money, to fund the impressive building we have today, built on the very site of Nelson's great mansion, Oak Hall, which was razed according to Nelson's daughter's will. Nelson's family attorney, who helped draw up the trust, and for whom Rozzelle Court is named, also left his money to the museum.

J. C. Nichols is another prominent figure who left a distinct mark on the city's landscape. To begin with, he was one of the trustees overseeing the early years of the Nelson-Atkins. Nichols got his start in the first decade of the twentieth century and in the beginning followed the lead of Nelson, developing near the Rockhill district and placing strong restrictive covenants on the developments. As his business progressed, he became concerned about the kind of retail businesses that might spring up near his subdivision and soon arrived at the idea of planned regional shopping centers. In this way he could control what the shops looked like, and often what kind of shops appeared. Country Club Plaza is the crowning example of such planning. It was Nichols who decided this shopping center should follow a Spanish theme and be modeled on Seville, Spain, Kansas City's sister city. Giralda Tower is a replica two-thirds the size of one in Seville. The Spanish Colonial style is achieved through the decorative tiles, tile roofs, and wrought ironwork. In addition, the Plaza contains more than thirty statues and fountains.

The Christmas light tradition began in December 1925. More photographs of Country Club Plaza, its Christmas lights, its towers and its fountains, were submitted than for any other single subject. The Plaza development demonstrates how much influence a single figure can have on a city's space. Now the district is home to one of the densest groups of apartment dwellers in the city.

Nichols, along with lumberman R. A. Long, chaired the campaign to build another one of the most photographed sites of the contest, Liberty Memorial, a tower monument and museum south of Union Station. This memorial was to honor the servicemen of World War I, but in addition was to beautify the area south of Union Station. In about ten days of intensive fund-raising during 1919, two million dollars were raised for the project. As a matter of fact, at one time this area was to have been the home of a civic center, and even the trustees of Nelson and Atkins considered this site. Instead, today one can visit displays explaining the causes of World War I, study the American role in it, see

articles of clothing and equipment used by the American doughboy, and be inspired by the Torch of Liberty. In addition, the Memorial mall is used for events like the Kansas City Blues and Jazz Festival.

While the photograph of the corporate jet landing at the downtown airport may symbolize the aggregation of big business in the city, other photographs reflect smaller businesses such as The Dime Store at Brookside, Planters, and the Opie Brush Co. Another group of images reveals the photographers' interest in functional structures that expose their geometric shapes, such as Channel Five's tower or the West Bottoms Bridge. This same interest in form following industrial function is apparent in the photograph of the National Starch plant.

There is no gainsaying that very large monumental structures not only dominate important spaces in the city's landscape but are the images that come to most people's minds when thinking about Kansas City. Whether it be the stadiums of the Chiefs and the Royals, whose images are often televised, the Plaza or the Liberty Memorial, Kemper Arena or the array of sky-

scrapers forming the skyline that greets the visitor and the commuter on the way to work, each constitutes a large part of the spatial composition we call Kansas City.

That said, most of us do not live most of our lives within the large monumental spaces, but in our homes in the quiet neighborhoods that abound. Here, artful small gardens and fountains lend grace to where we live. The mini-gardens at 68th and Brookside Road or at Meyer Boulevard and Oak are typical examples. Too, there is no harm is saying again that Kansas City has more fountains than any other American city. All of which is not to say that all areas of metropolitan Kansas City are equally graceful, whether because people in some neighborhoods have taken little interest in such things, or because the developer did not see it in his overall interest to include such felicities in his plans. On balance, however, these photographs are ample proof that Kansas City is one of the country's most desirable places to live, a fact further evidenced by the city's prosperity and growing population.

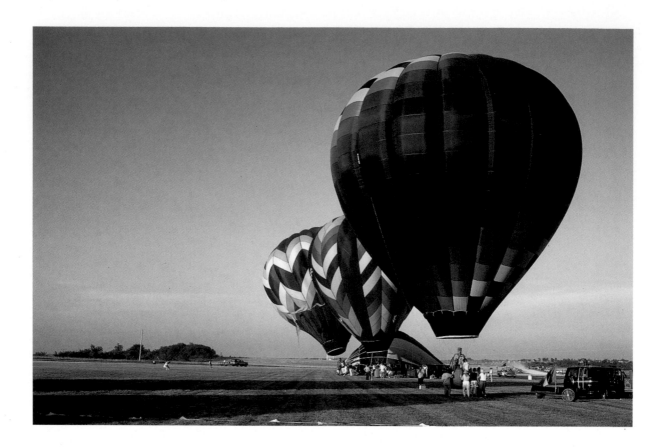

A hot air balloon race at Richards Gebaur Air Force Base. HARLAN SMITH

The Kansas City Blues and Jazz Festival, held on the lawn of Liberty Memorial. YVONNE O'BRIEN

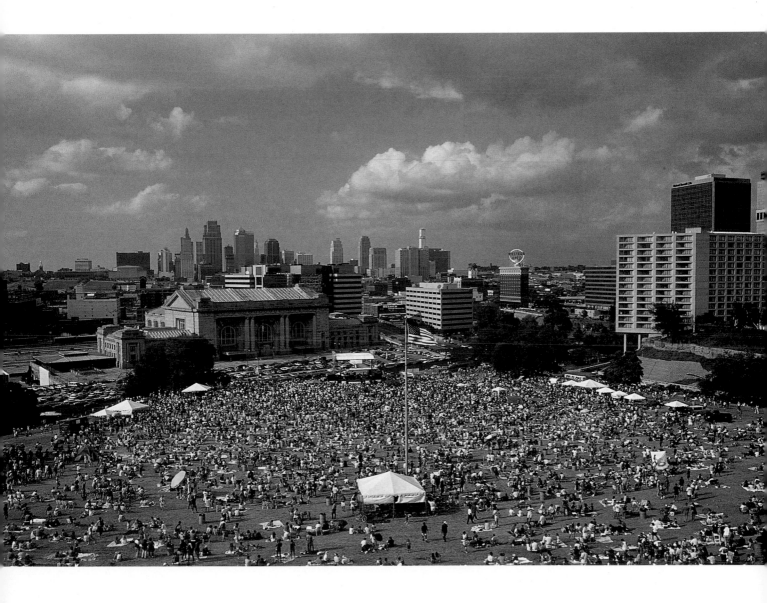

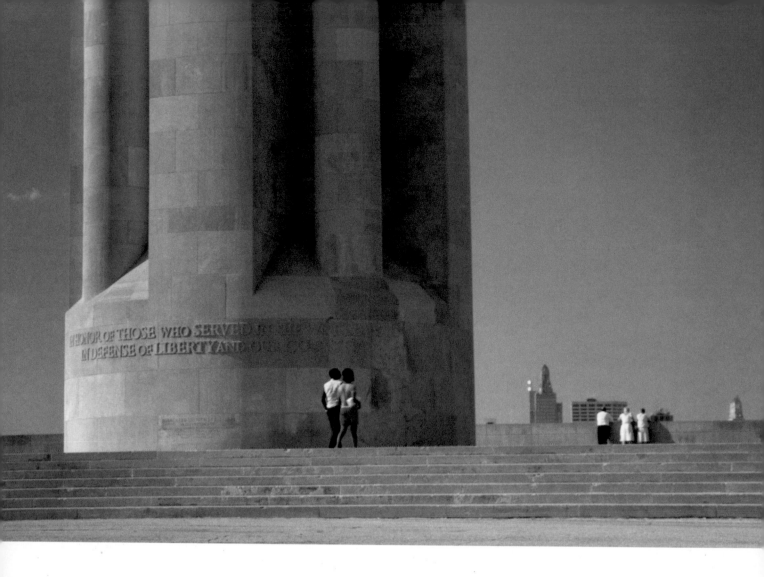

The base of Liberty Memorial. CURTIS VANWYE

Concert time, rain or shine, on the lawn of Liberty Memorial. YVONNE
O'BRIEN

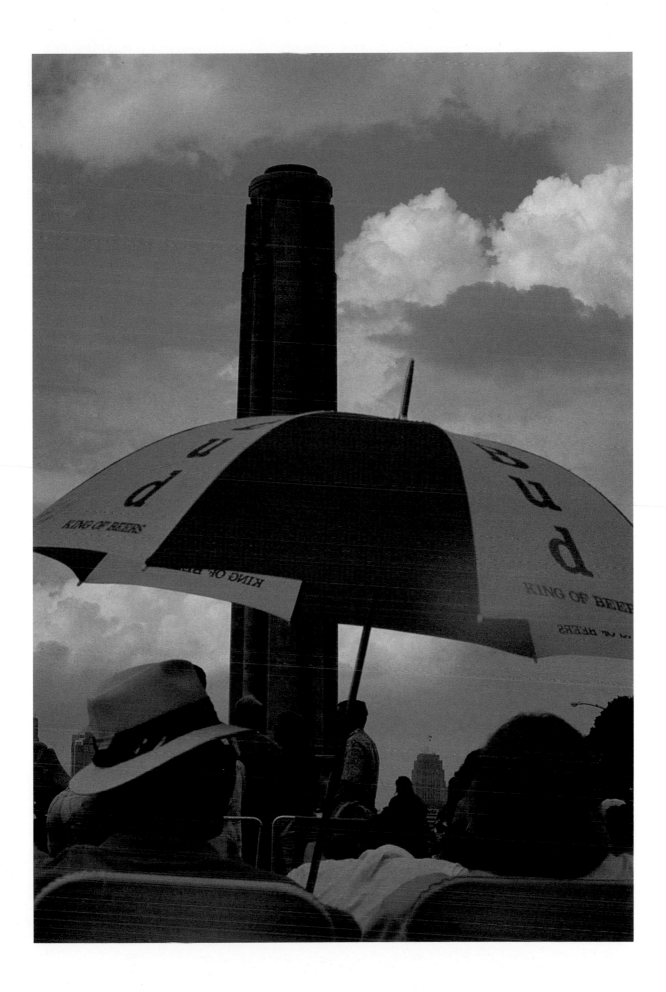

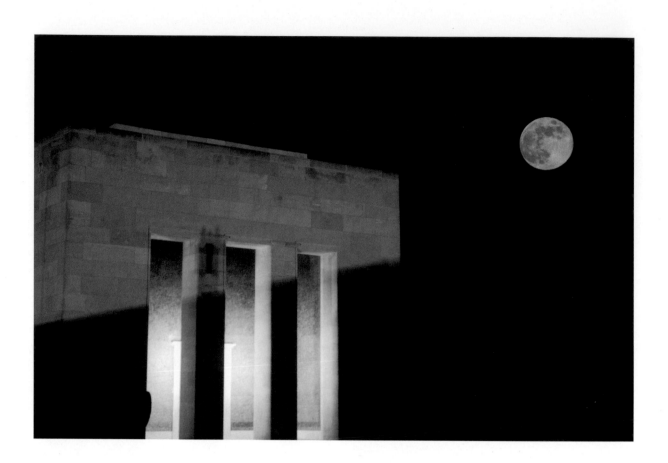

Liberty Memorial. MICHAEL ALAN BAILEY (ABOVE) AND YVONNE O'BRIEN (RIGHT)

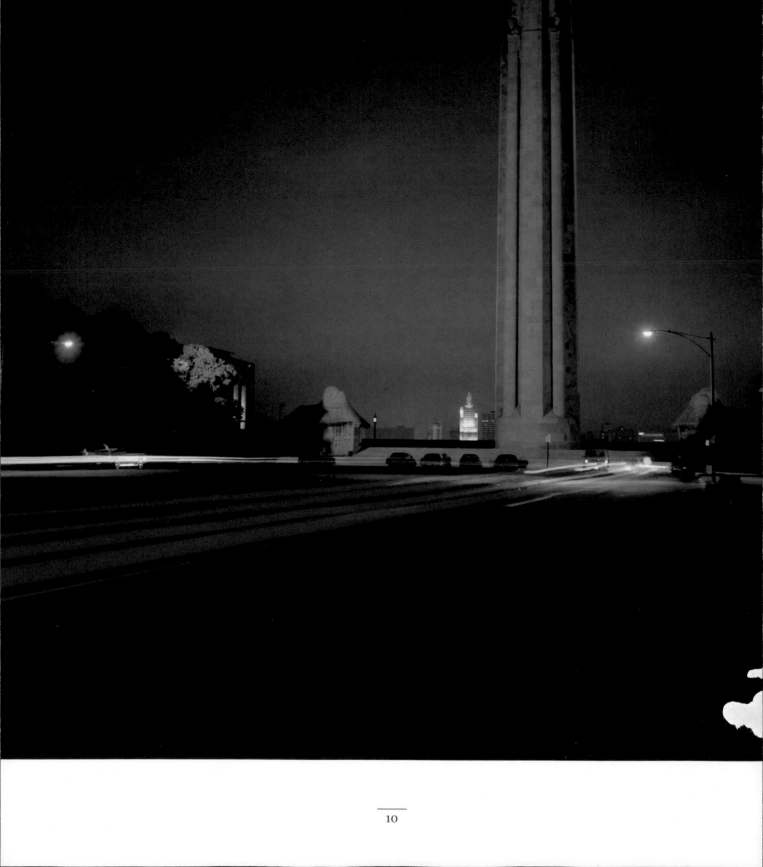

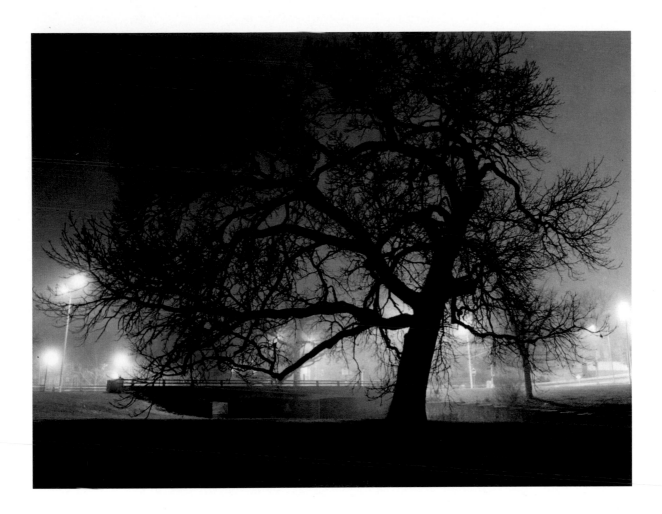

Night scenes. CURTIS VANWYE (LEFT) AND PAUL R. RANDALL (ABOVE)

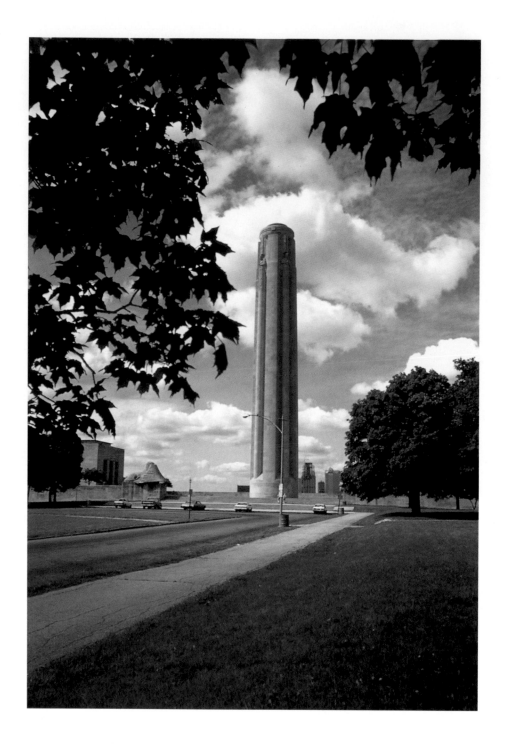

Liberty Memorial. BART LARSON

Tulips and walkway at the Kansas City Museum. SHELLEY L. DENNIS

Girls and umbrellas. GREG SLEE

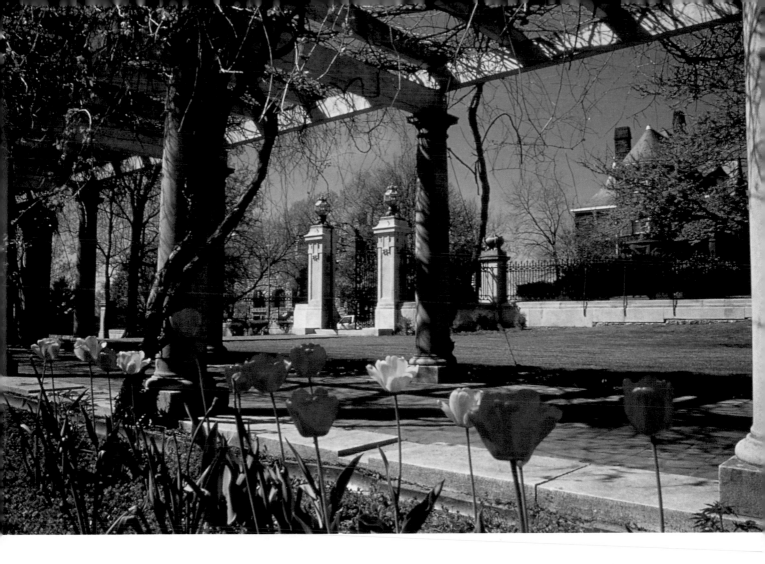

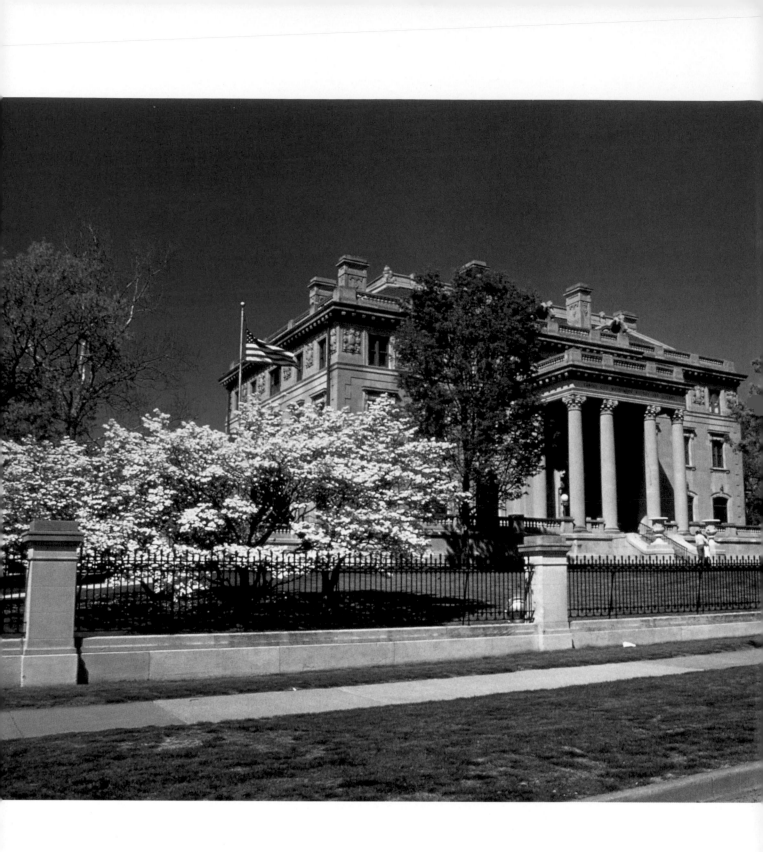

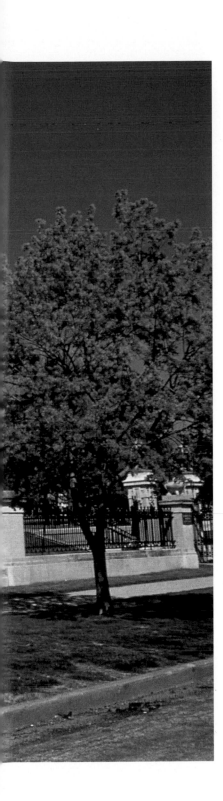

The Kansas City Museum. SHELLEY L. DENNIS

The roof of Rozzelle Court inside the Nelson-Atkins Museum of Art. YVONNE O'BRIEN

Overleaf: Claes Oldenburg's shuttlecocks on the lawn of the Nelson-Atkins Museum. PAT JESAITIS

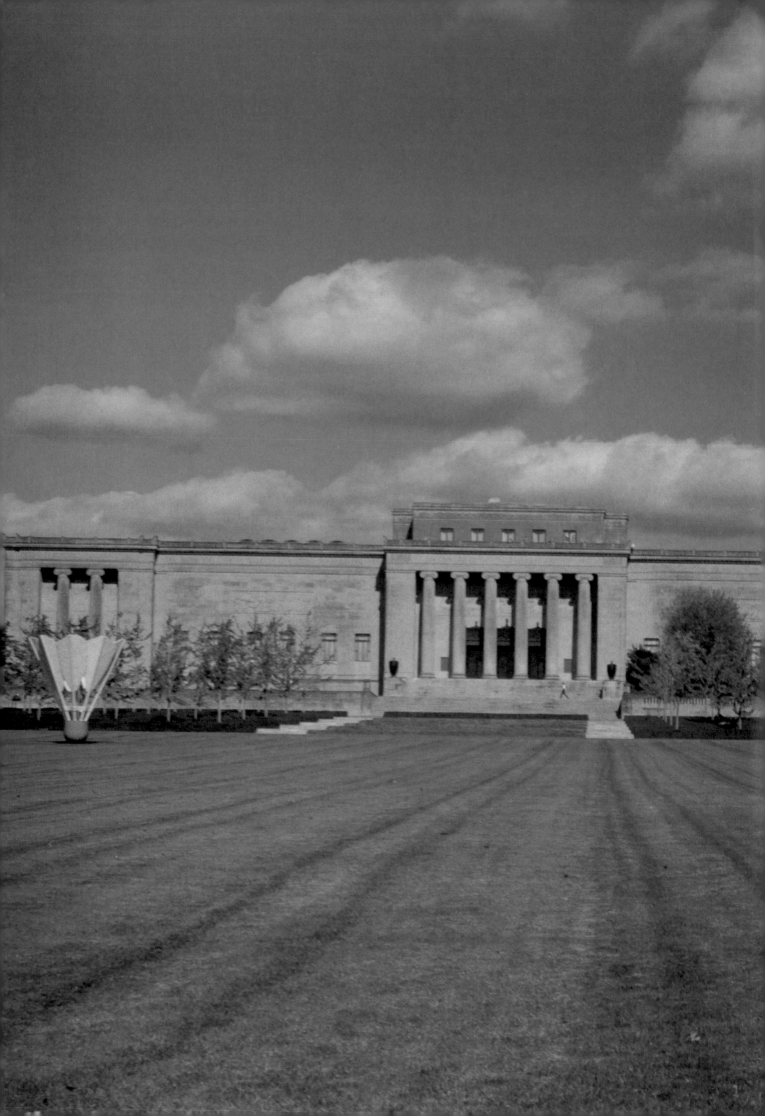

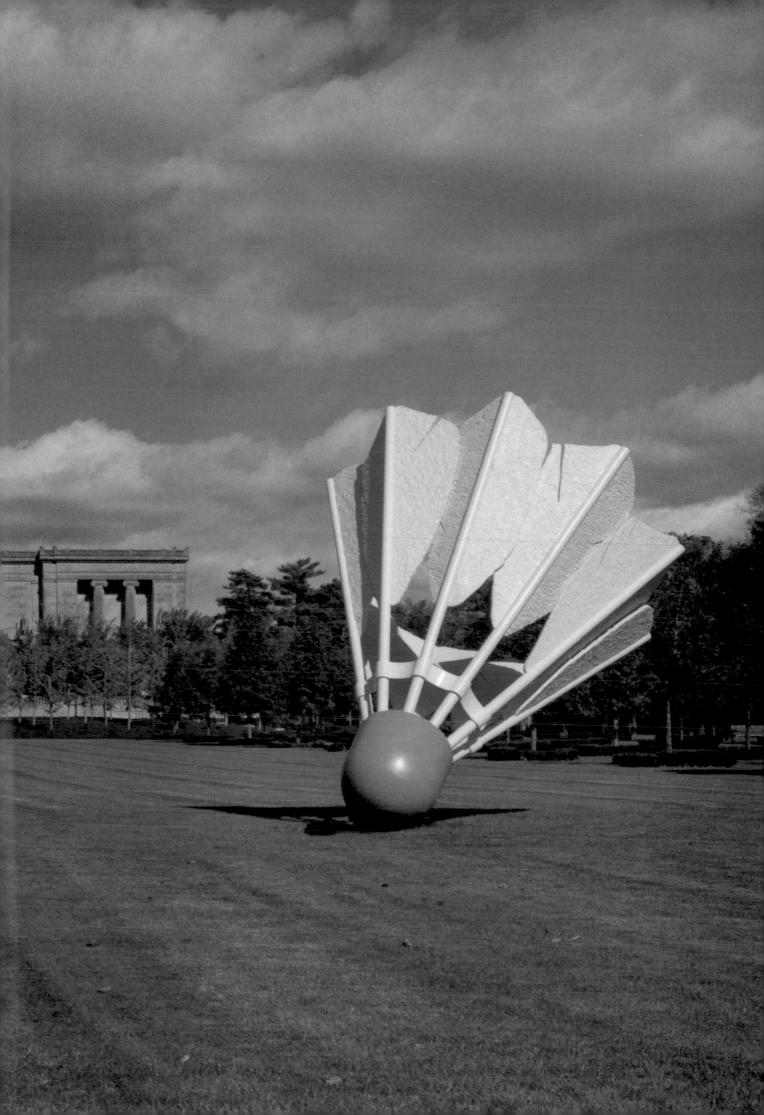

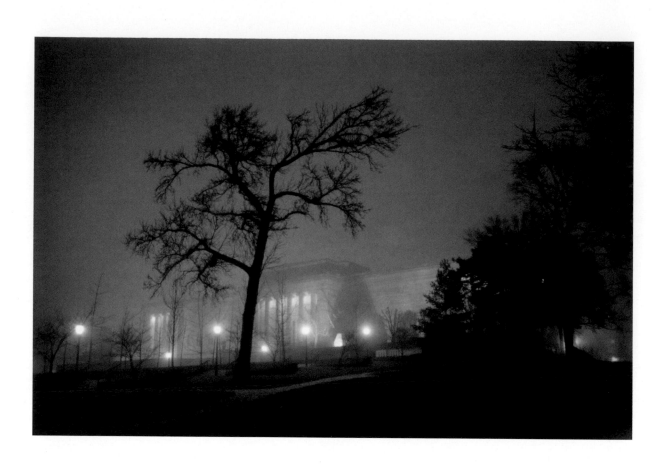

The Nelson-Atkins Museum at night. MICHAEL ALAN BAILEY

Luminarias lit in honor of those served by Kansas City's hospice
organization. YVONNE O'BRIEN

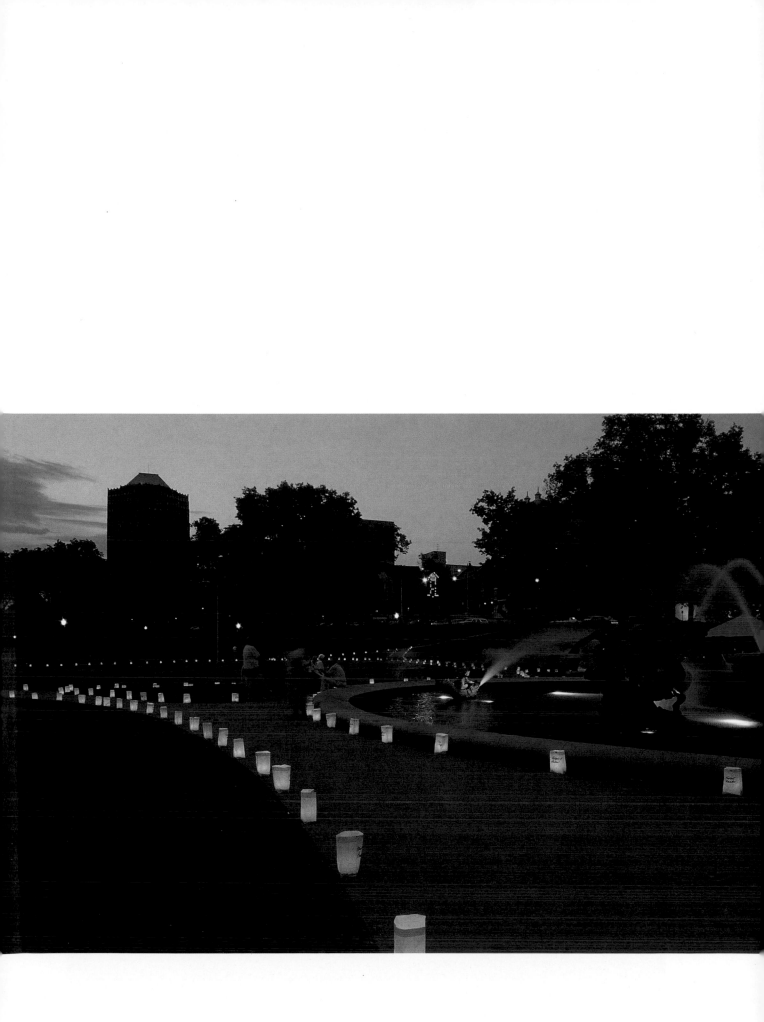

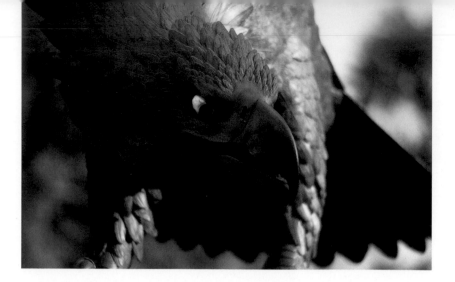

Eagle sculpture at 67th and Ward Parkway. HARLAN SMITH

Nelson-Atkins Museum. TERRANCE MCGRAW

Federal Building and American flag. TERRANCE MCGRAW

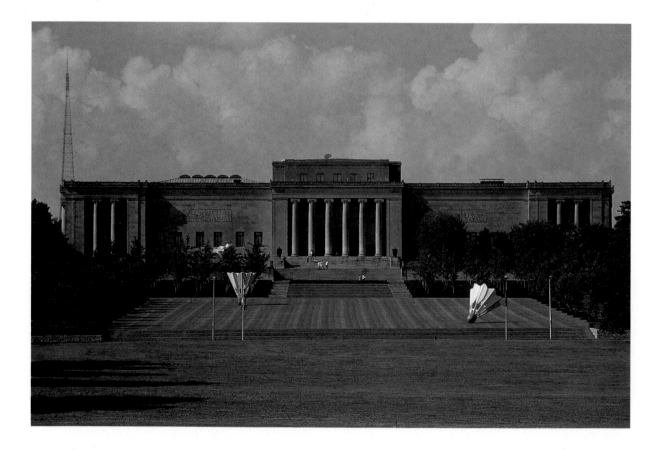

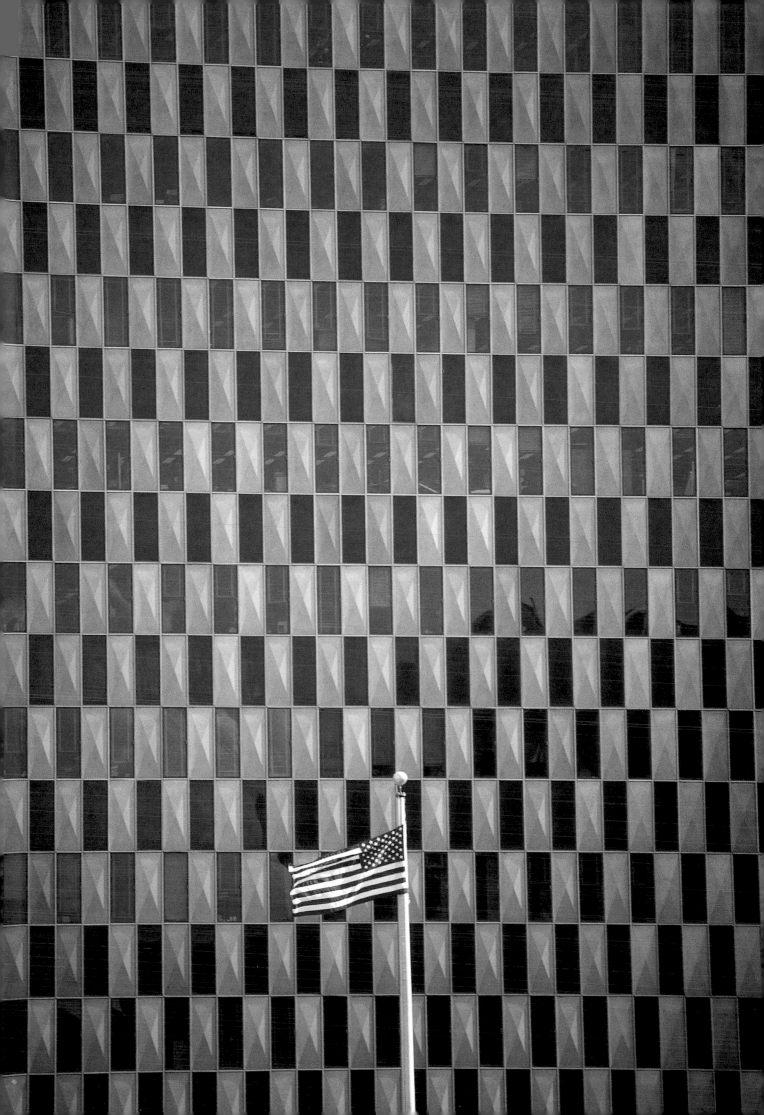

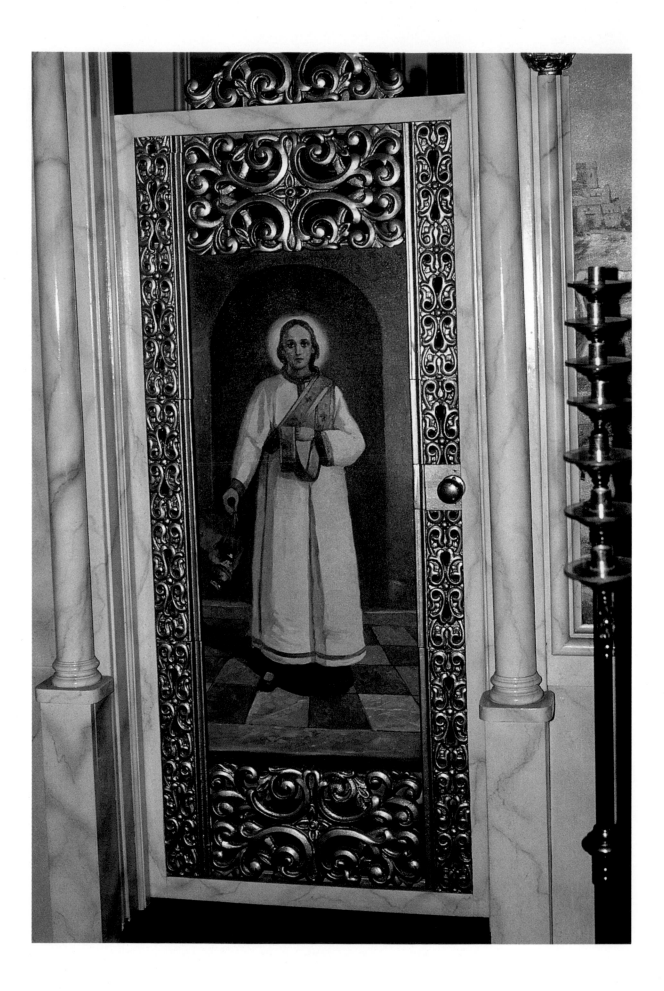

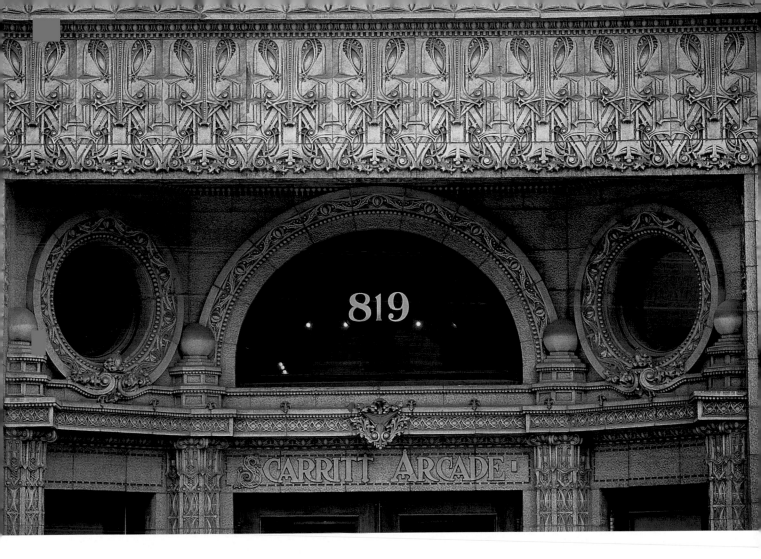

An icon inside St. George's Serbian Orthodox Church. LINDA BRUNK SMITH

Facade of the Scarritt Arcade Building. TERRANCE MCGRAW

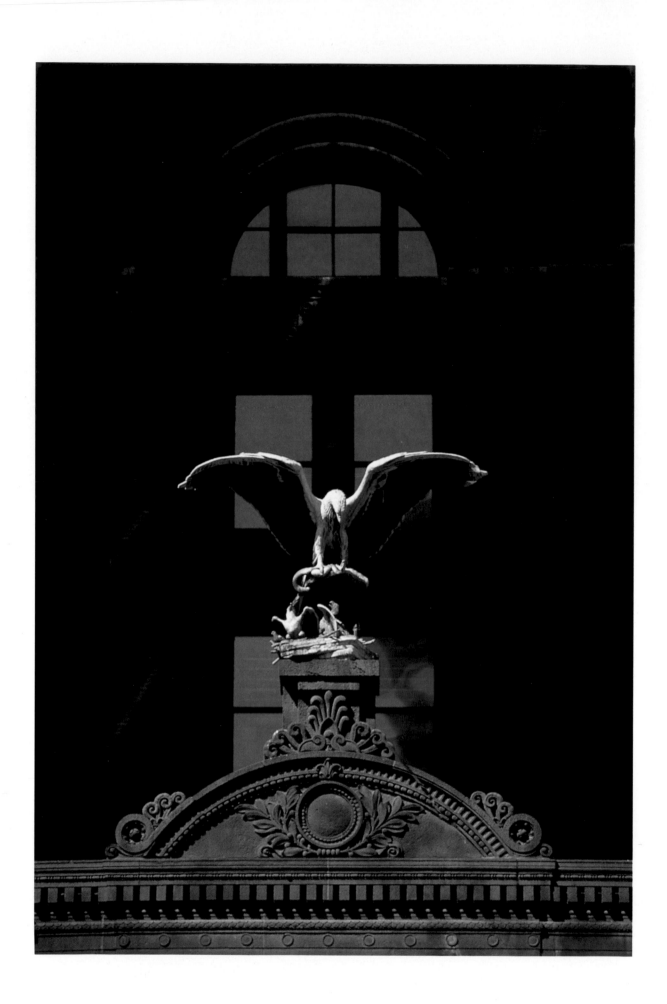

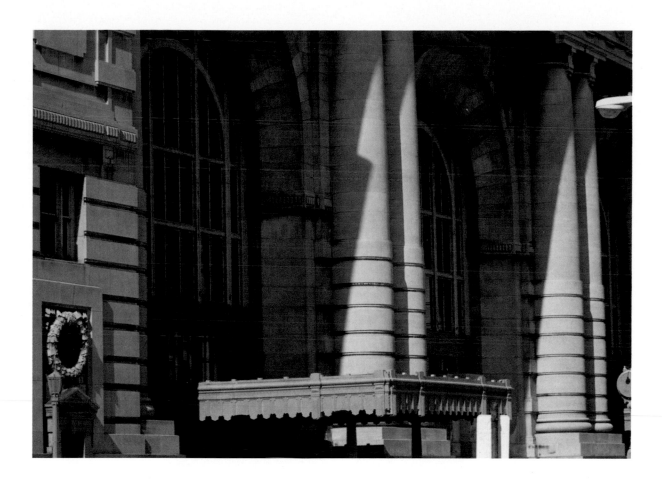

The eagle atop the New York Life Building at 9th and Baltimore.
TERRANCE MCGRAW

Union Station. MICHAEL ALAN BAILEY

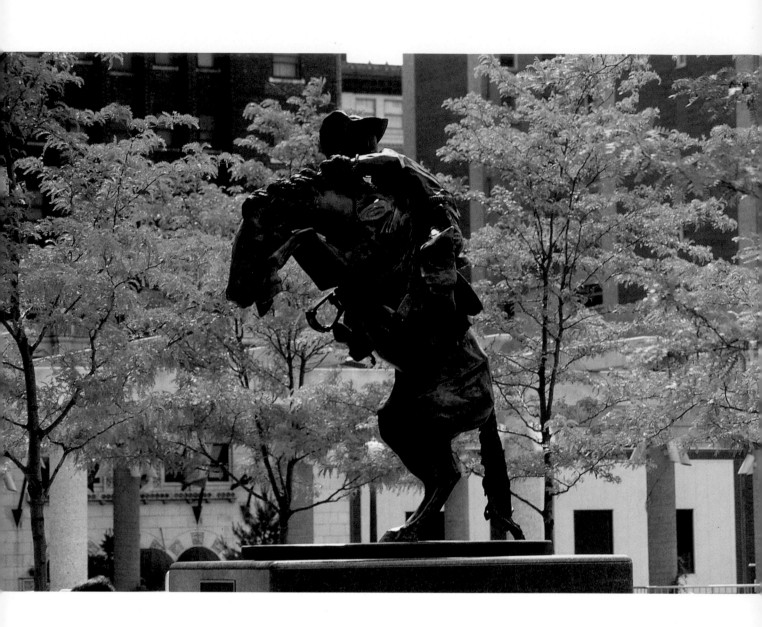

Bronco Buster, Barney Allis Plaza. BART LARSON

Nichols Fountain, Country Club Plaza. MICHAEL ALAN BAILEY

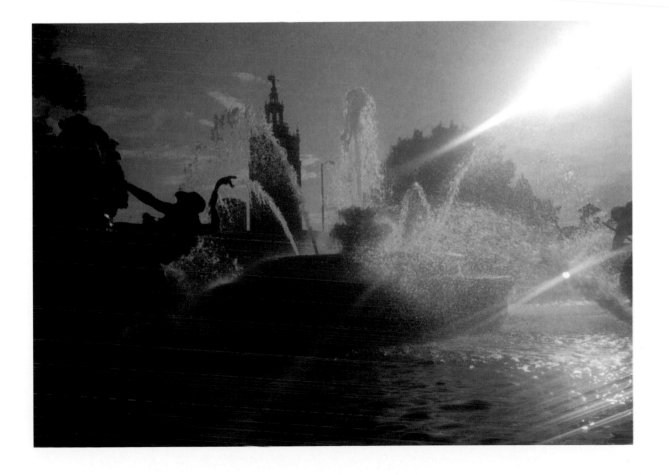

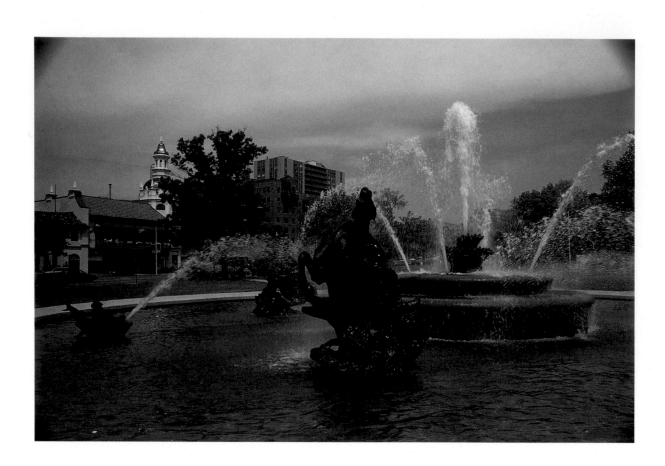

Plaza fountains. BART LARSON (ABOVE), WILLIAM HELVEY (RIGHT),
AND TERESA NEUNER (OVERLEAF)

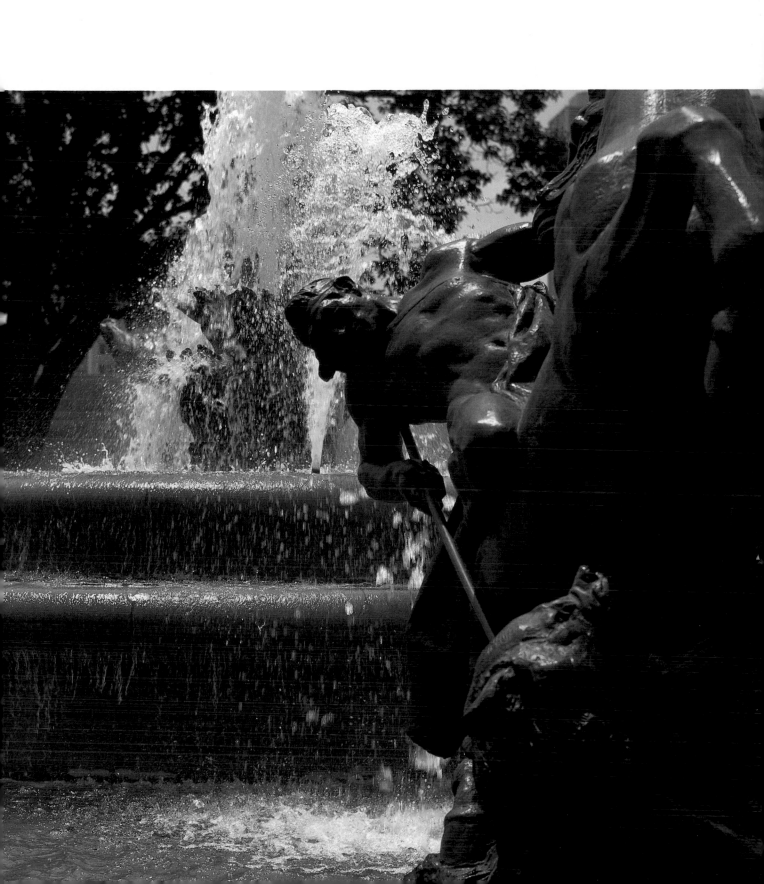

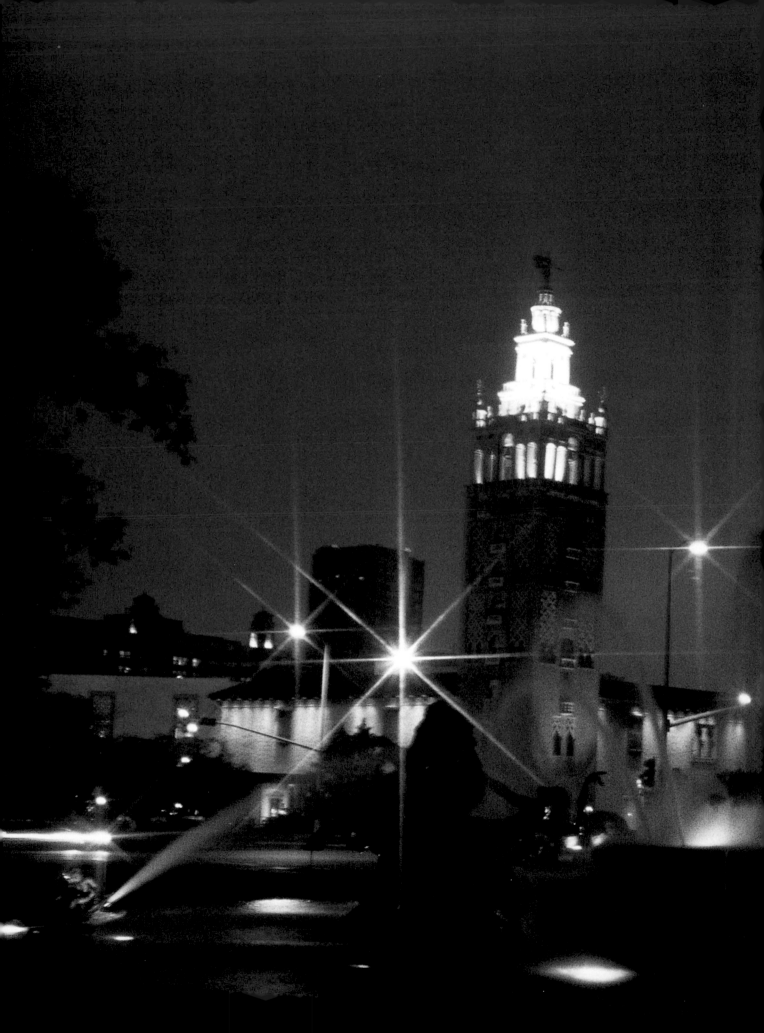

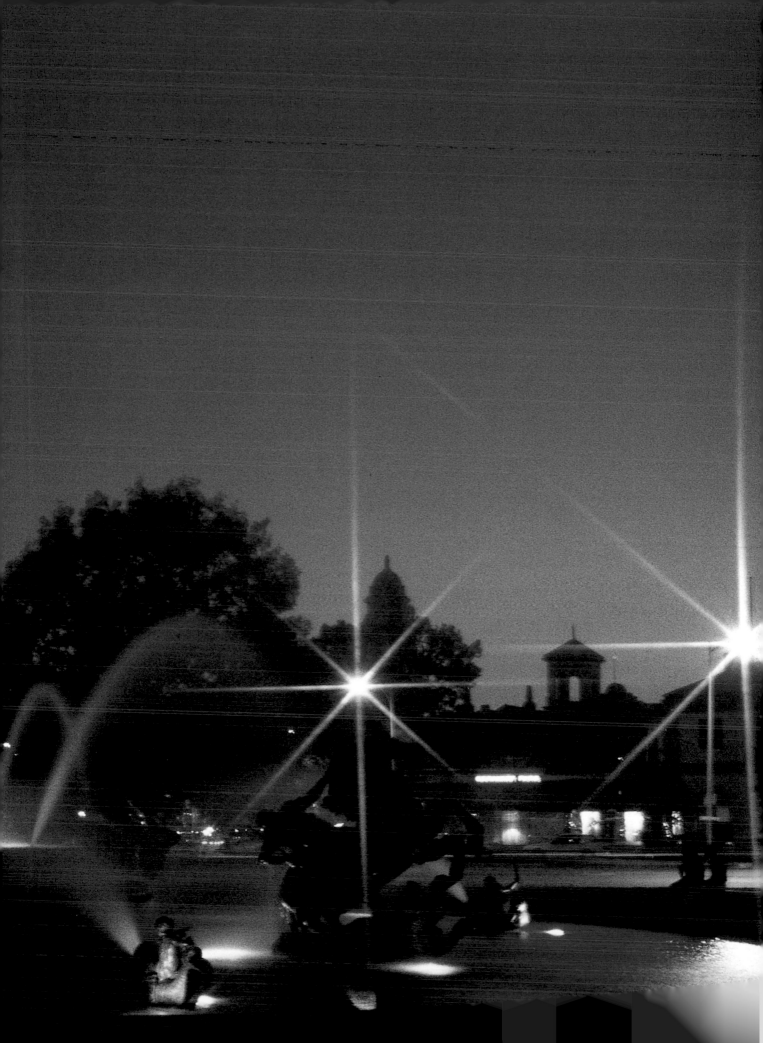

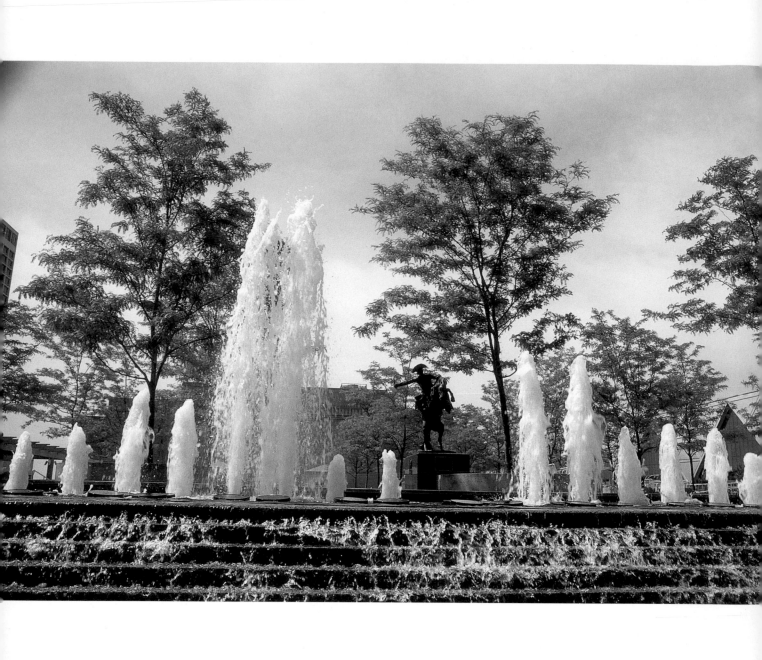

Plaza fountain. BART LARSON

The Children's Fountain. PAT JESAITIS

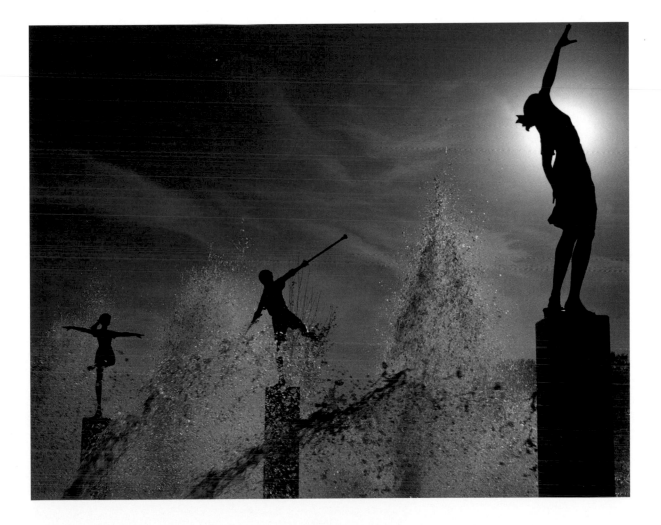

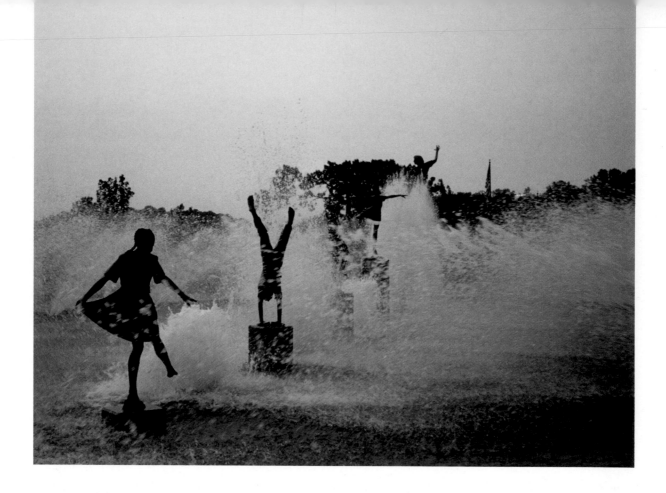

Two views of the Children's Fountain. LINDA H. COZAD

Brush Creek at night. TERRANCE MCGRAW

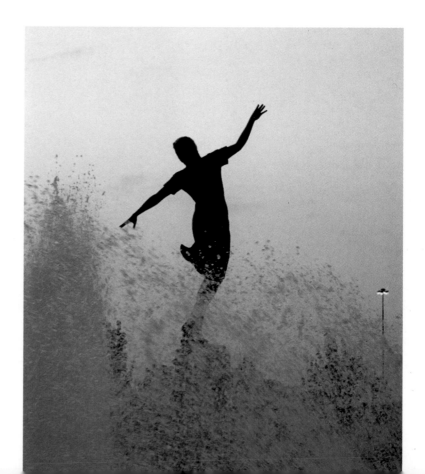

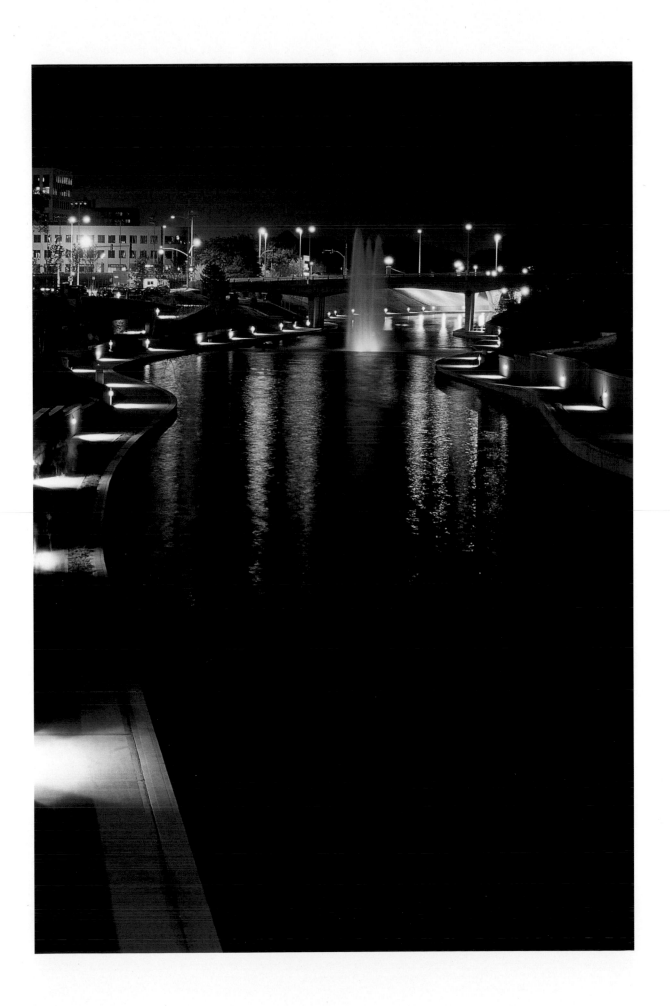

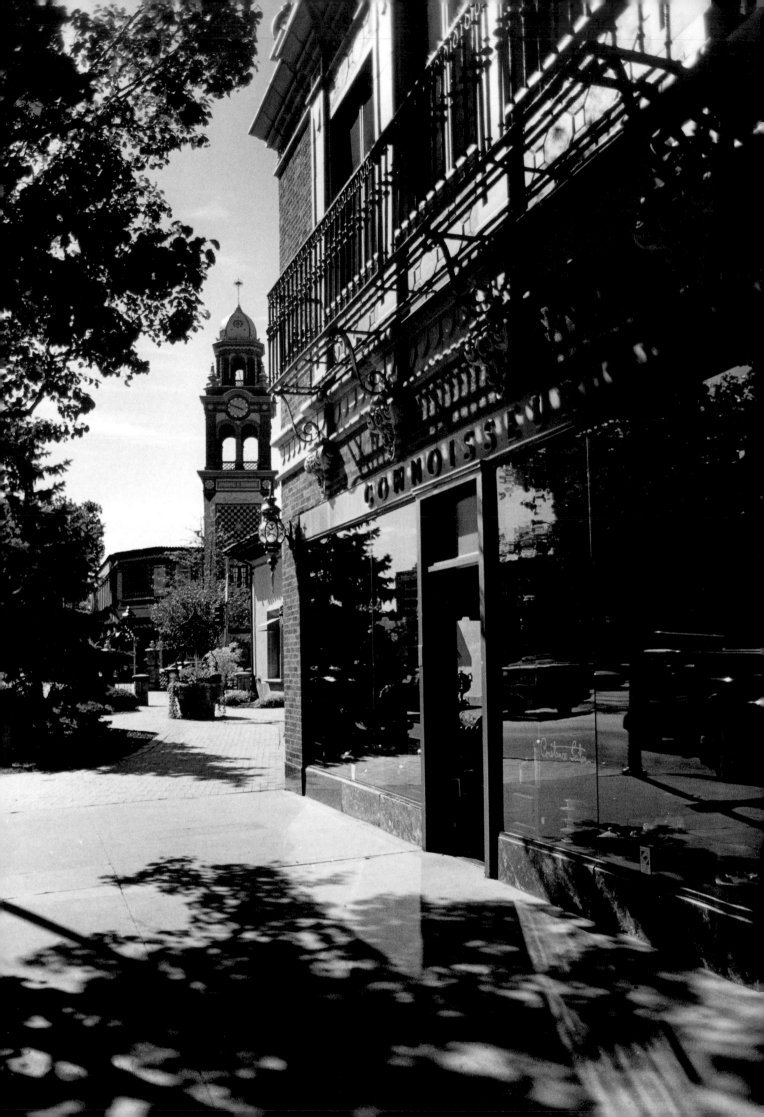

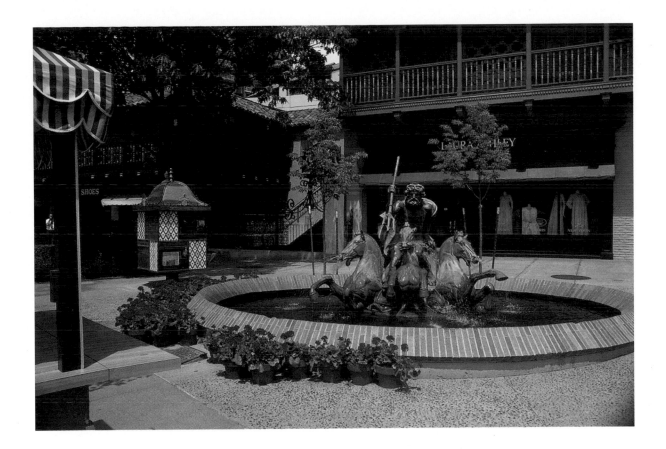

Plaza scenes. CHRISTINA MCPHEE (LEFT) AND BART LARSON (ABOVE)

Cleome flowers at dawn in Loose Park Garden Center. CHRISTINA MCPHEE

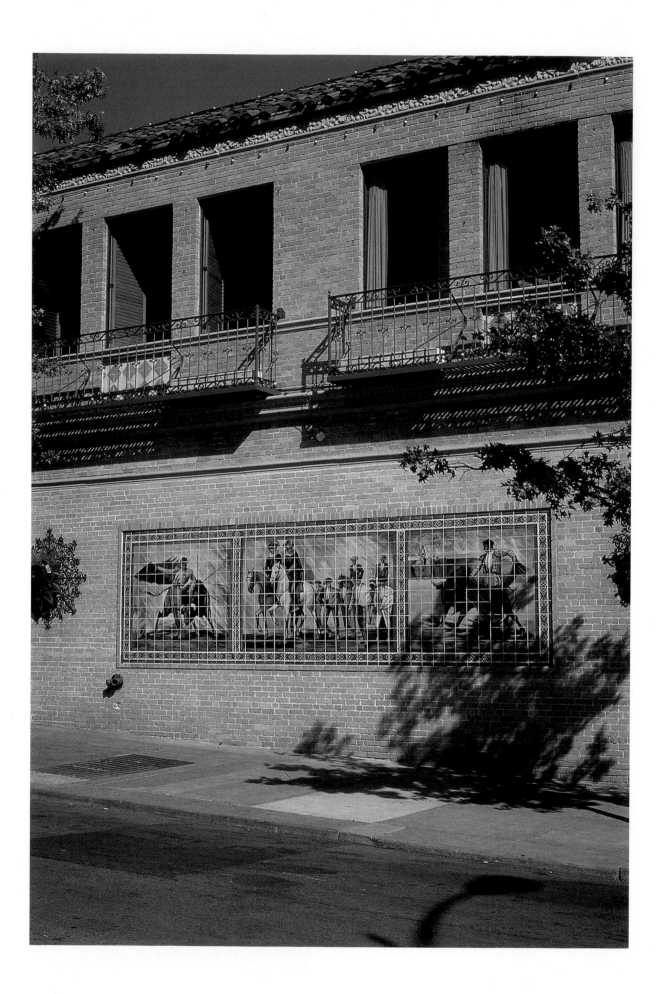

Plaza mosaic. JESSICA WITHINGTON

A sunbathed Plaza roof. WILLIAM HELVEY

Overleaf: *The Scout* overlooks downtown from
Penn Valley Park. SHELLEY L. DENNIS

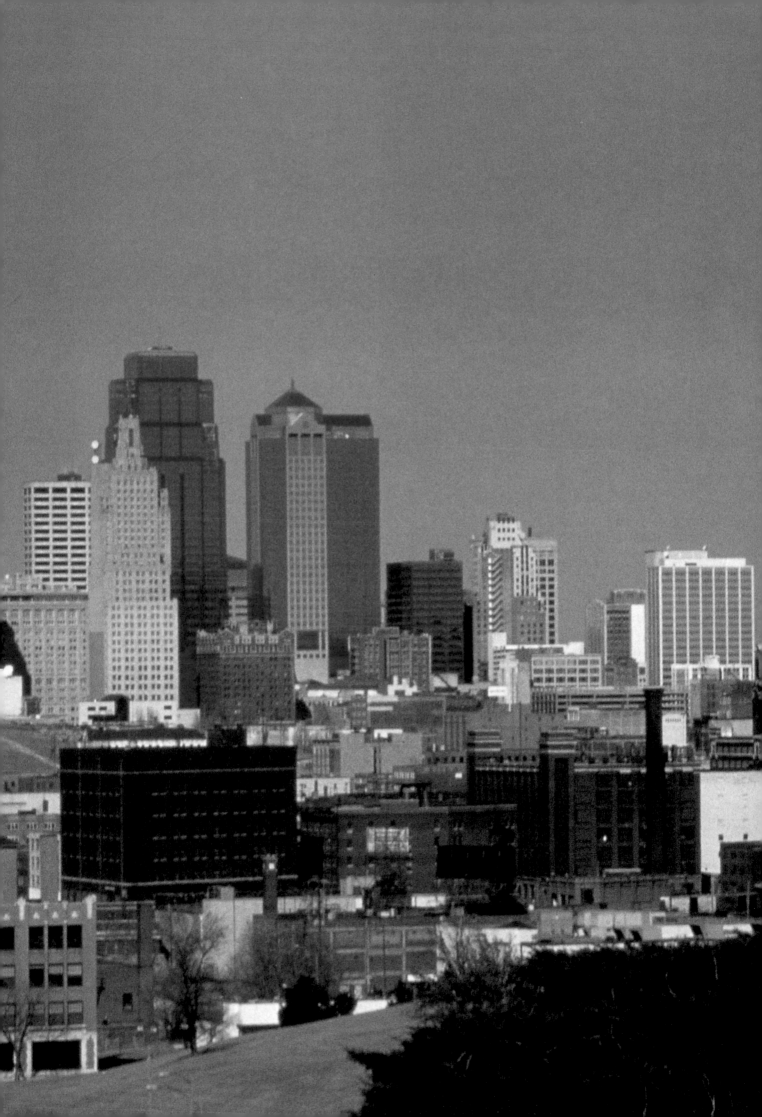

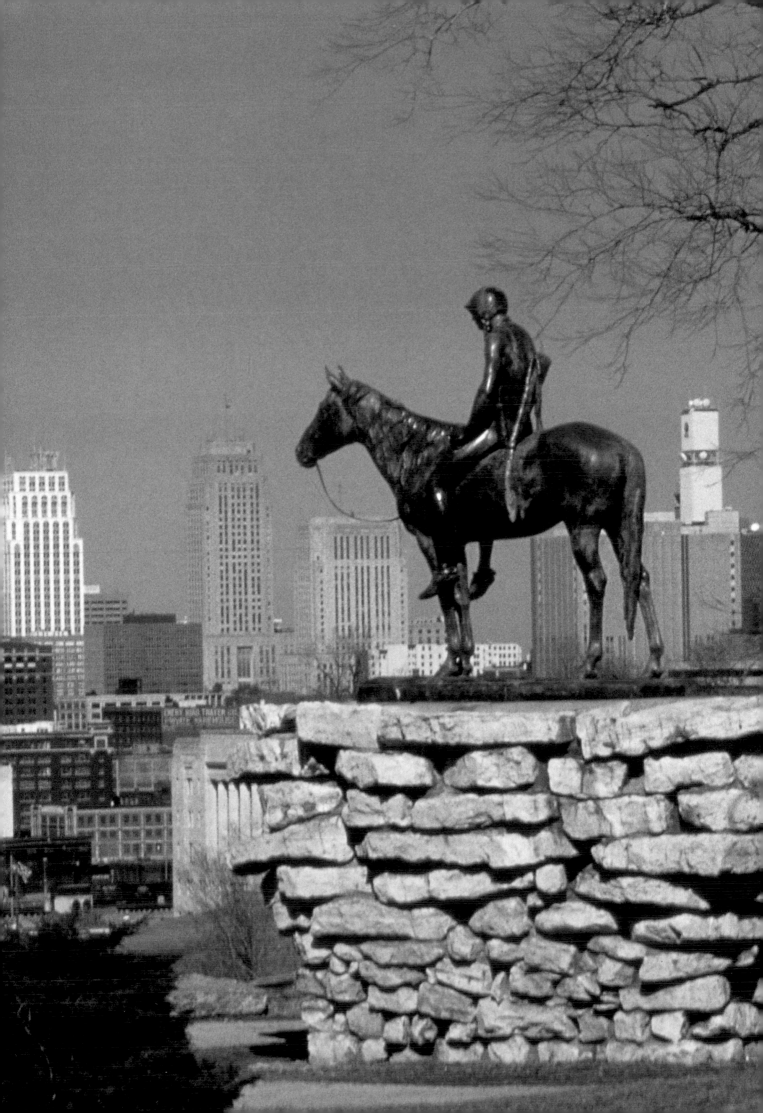

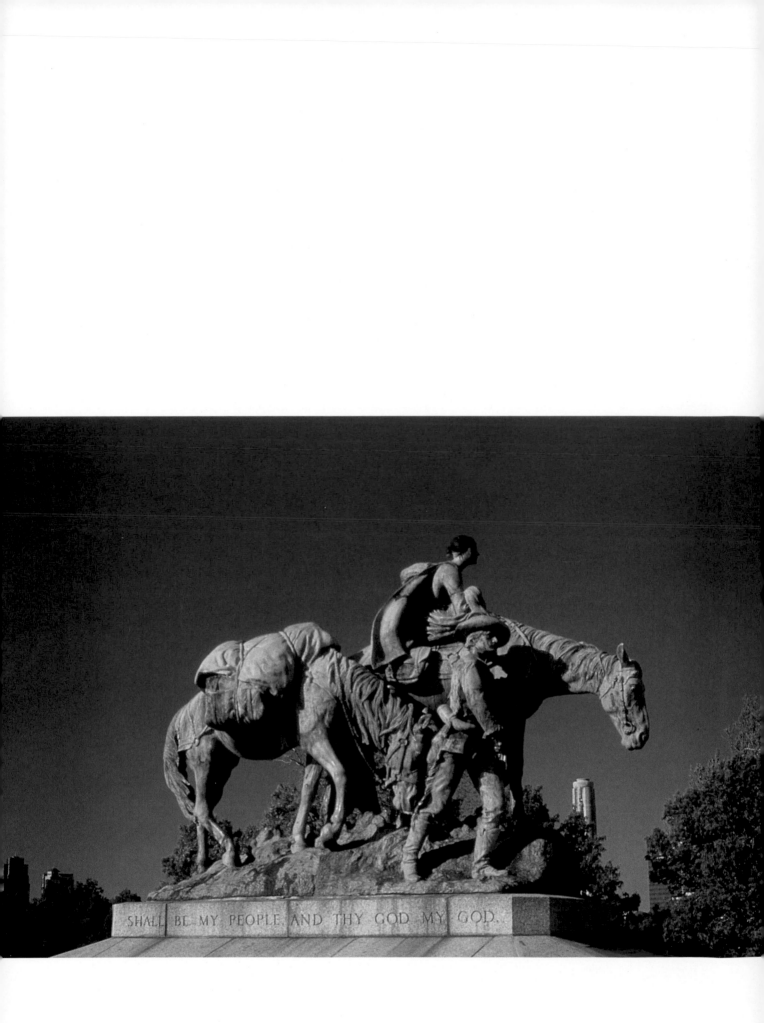

SHALL BE MY PEOPLE, AND THY GOD MY GOD.

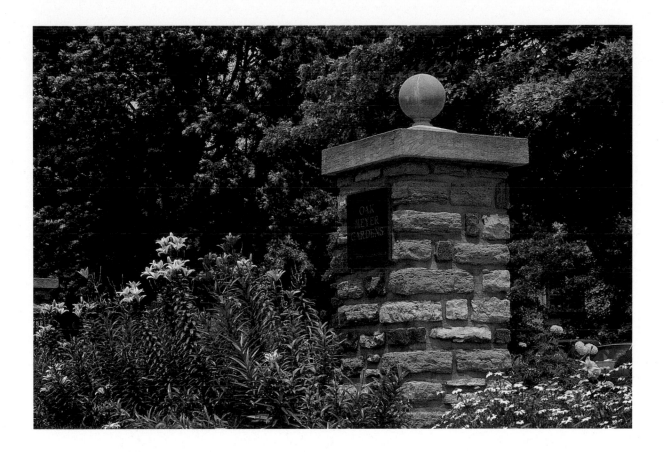

The Pioneer Mother, Penn Valley Park. SHELLEY L. DENNIS

Kansas City's boulevard system features many beautiful pocket gardens,
like this one at Meyer Boulevard and Oak. HARLAN SMITH

Ornately decorated house. JESSICA WITHINGTON

Mini-garden at 68th and Brookside Road. LINDA BRUNK SMITH

Jazz musicians visit the grave of Charlie Parker on the seventy-fifth anniversary of his birth. From left: John Gleason, Ahmad Alaadeen, and Ben D. Kynard. JANIS K. KINCAID

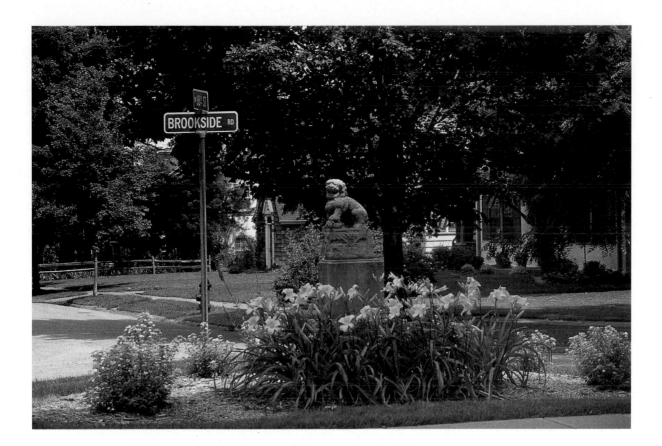

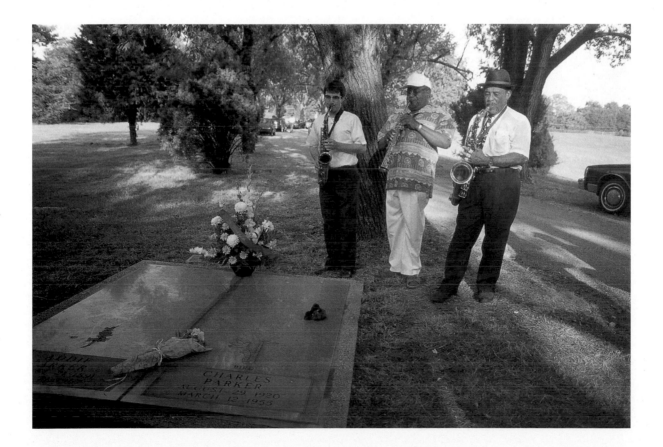

The Dime Store, a Kansas City institution since 1940. HARLAN SMITH

The Ethnic Festival in Swope Park features foods from different
cultures. LINDA BRUNK SMITH

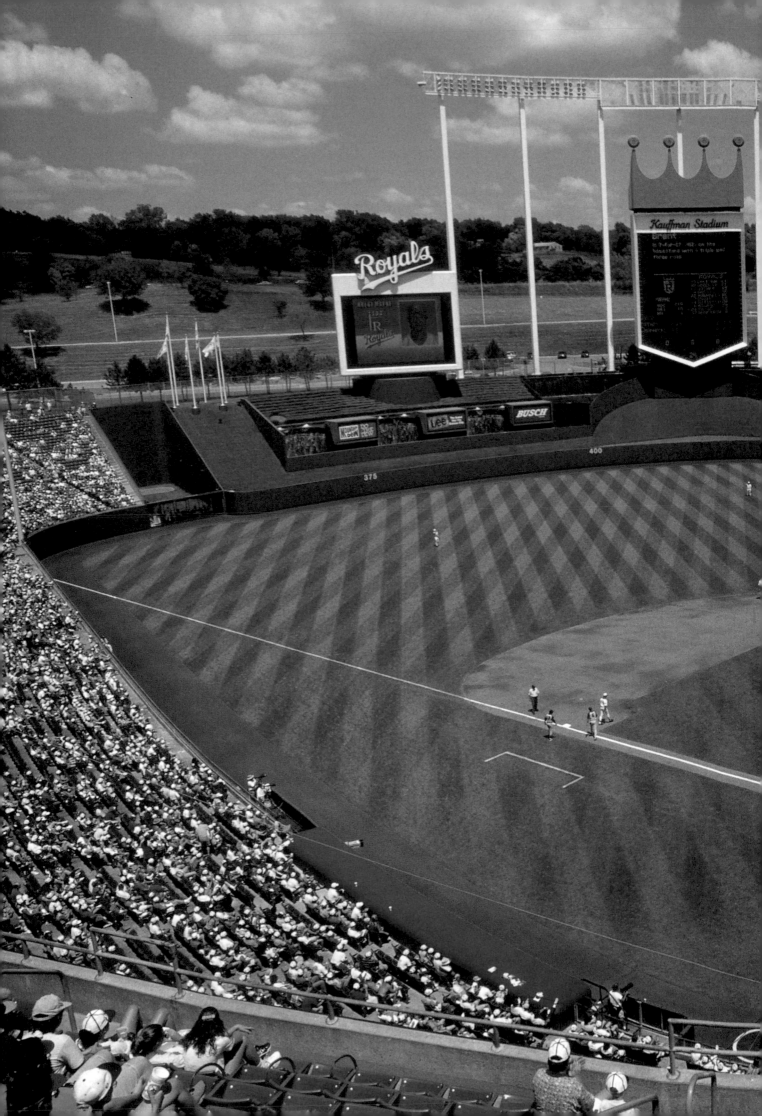

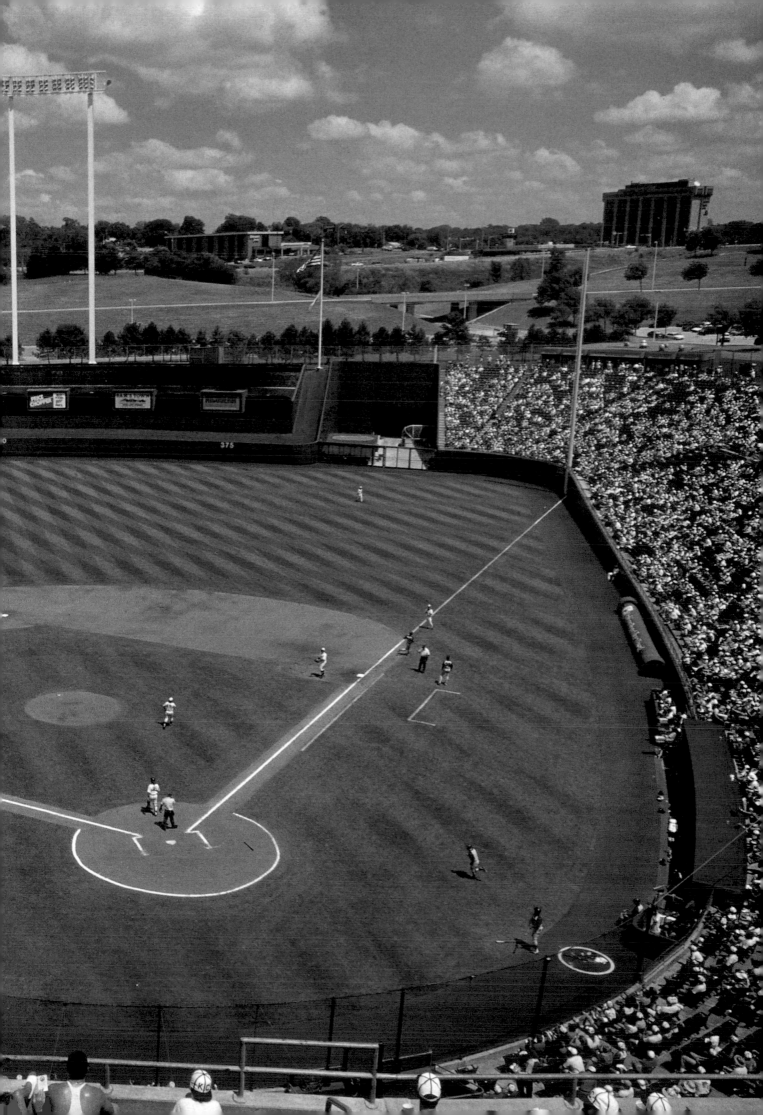

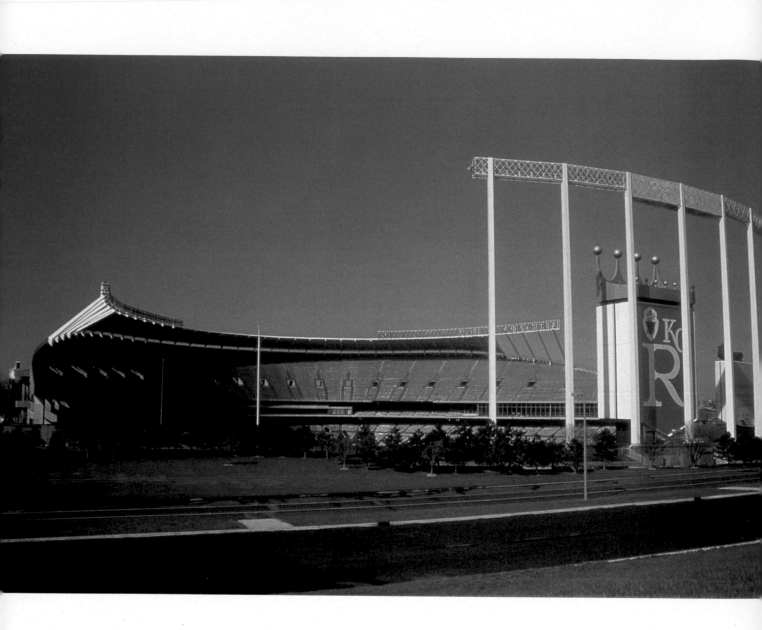

Royals Stadium. SHELLEY L. DENNIS

The Goodyear Blimp visited Kansas City for the telecast of a Chiefs game.
YVONNE O'BRIEN

Preceding pages: The Royals at home. CHRIS VLEISIDES

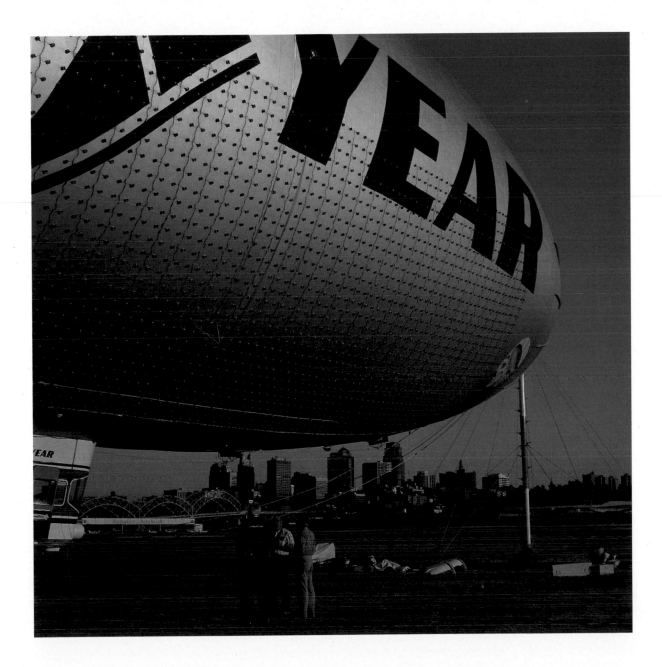

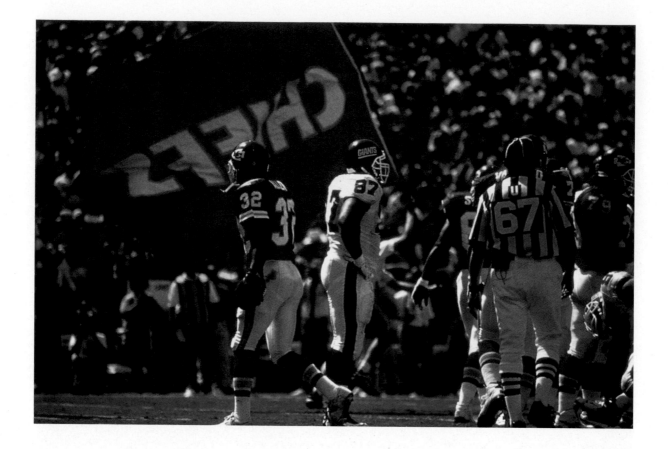

The Chiefs. HANK YOUNG

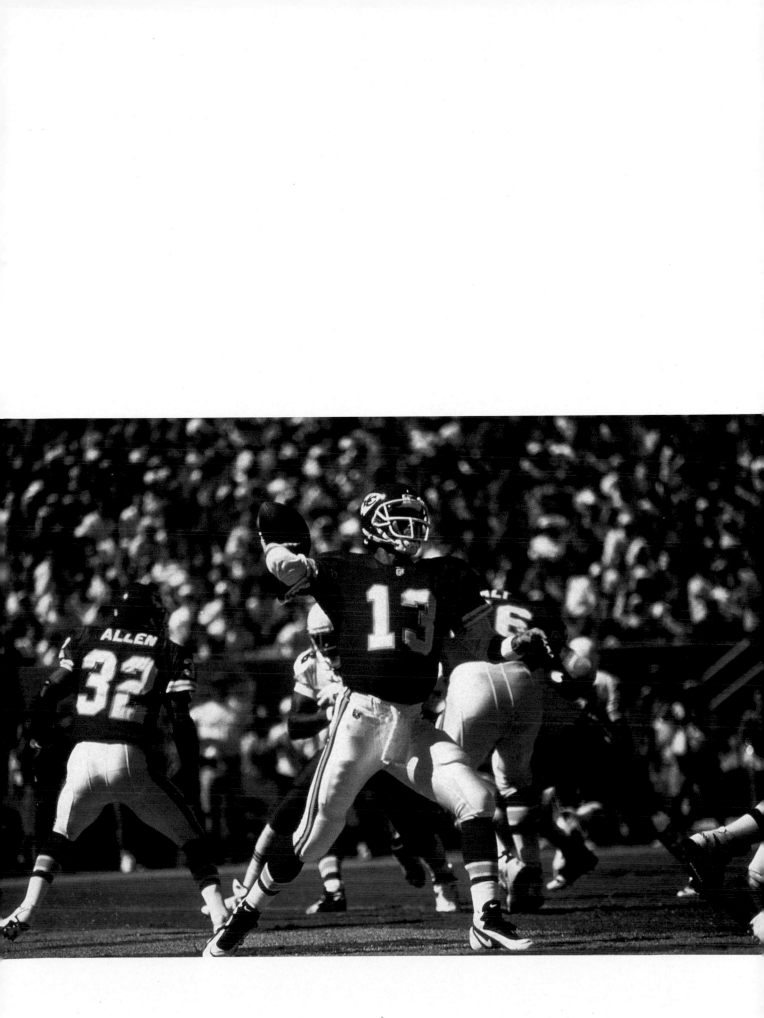

Worlds of Fun. GREG SLEE

A warthog at the Kansas City zoo. HARLAN SMITH

Liberty and Labor Day in their new pool at the zoo. HARLAN SMITH

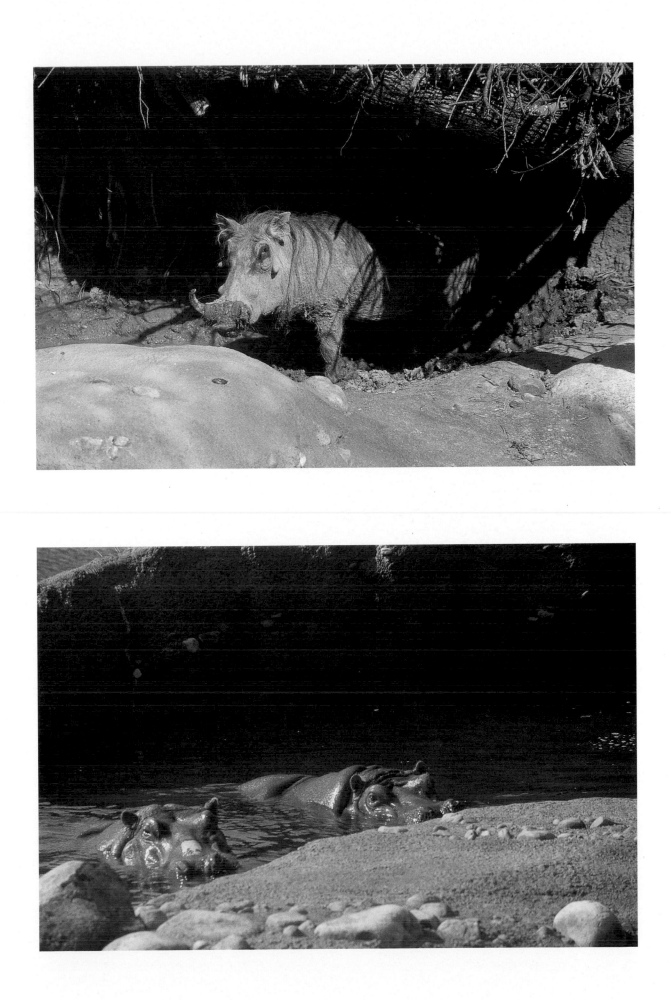

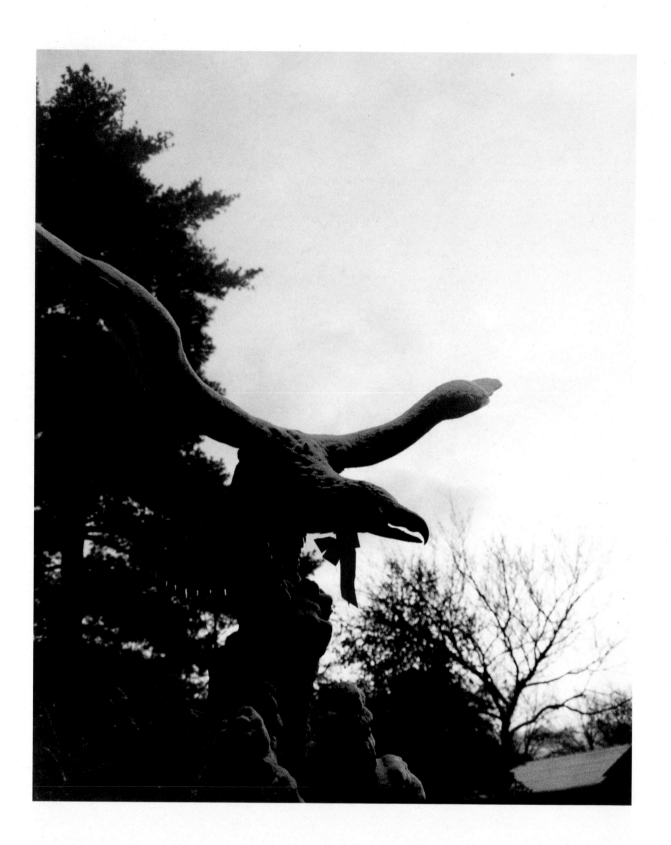

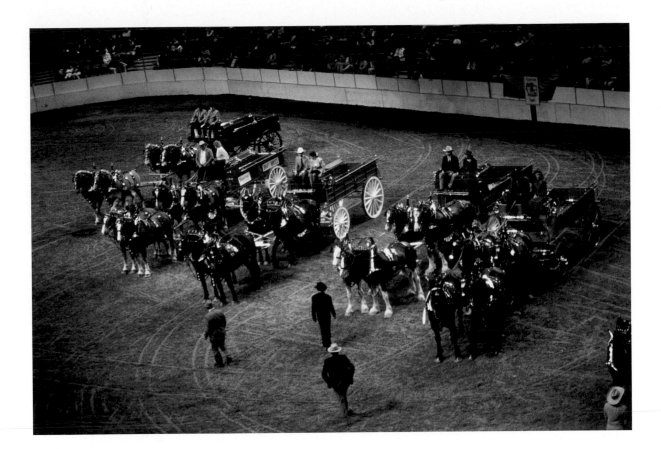

Eagle sculpture on Ward Parkway. PAUL R. RANDALL

American Royal Draft Horse Show at Kemper Arena. HARLAN SMITH

Overleaf: Skyline at sunset. BART LARSON

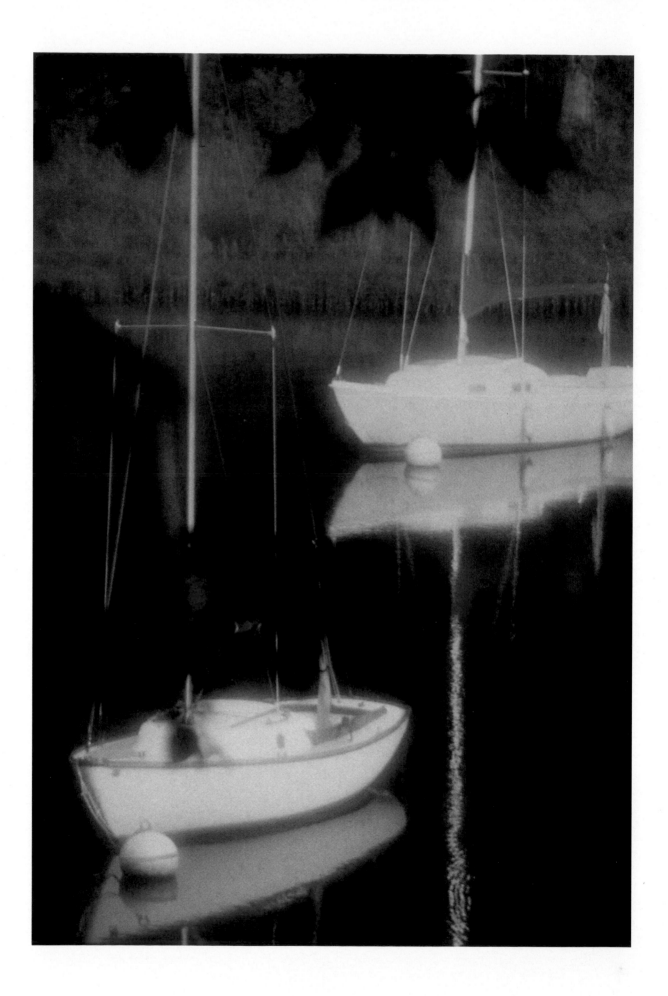

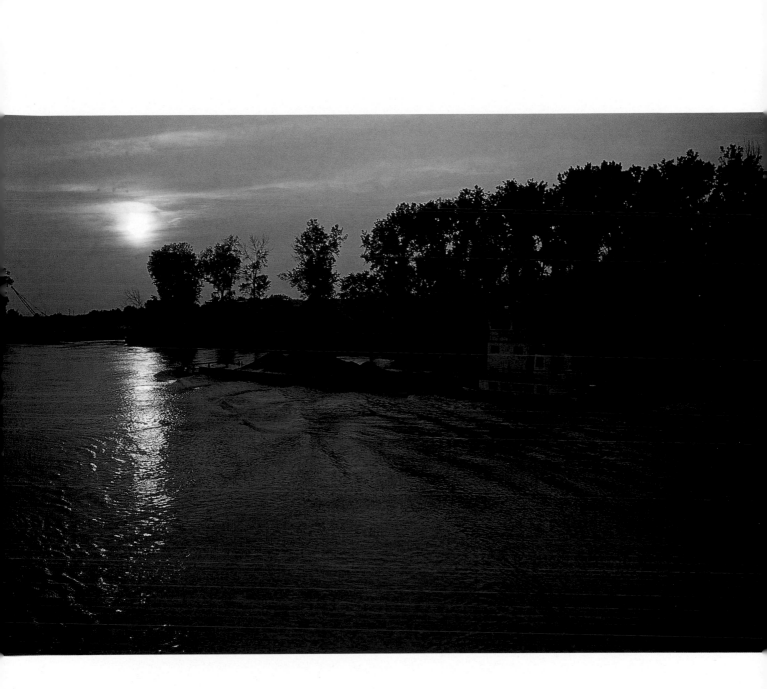

Lake Jacomo, Lee's Summit. MICHAEL ALAN BAILEY

Sunset on the Missouri River. WILLIAM HELVEY

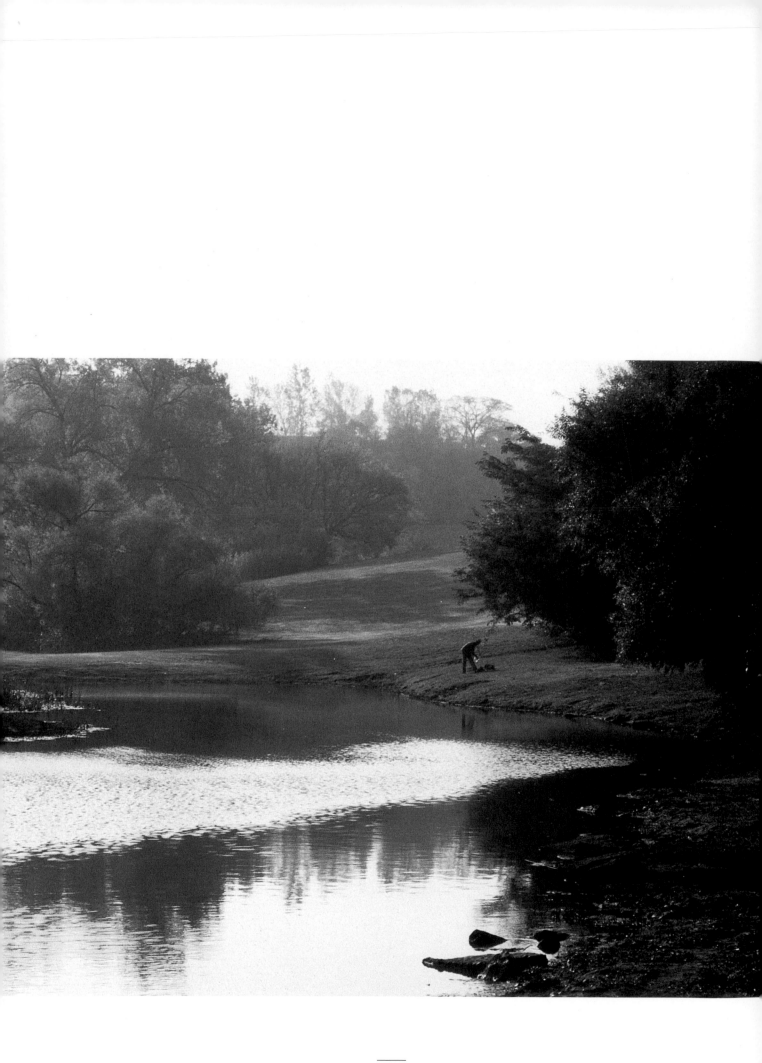

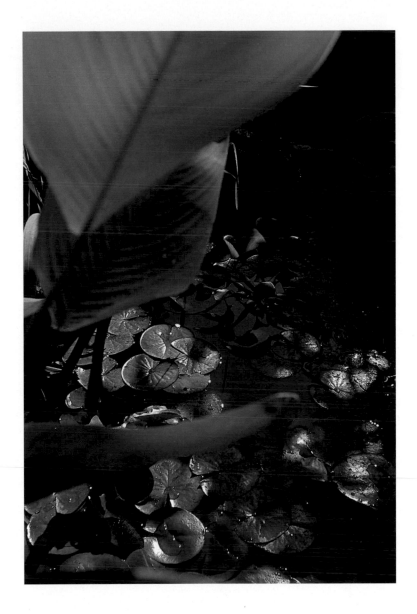

Fishing in Penn Valley Park. PAT JESAITIS

Water lilies at Powell Gardens. WILLIAM HELVEY

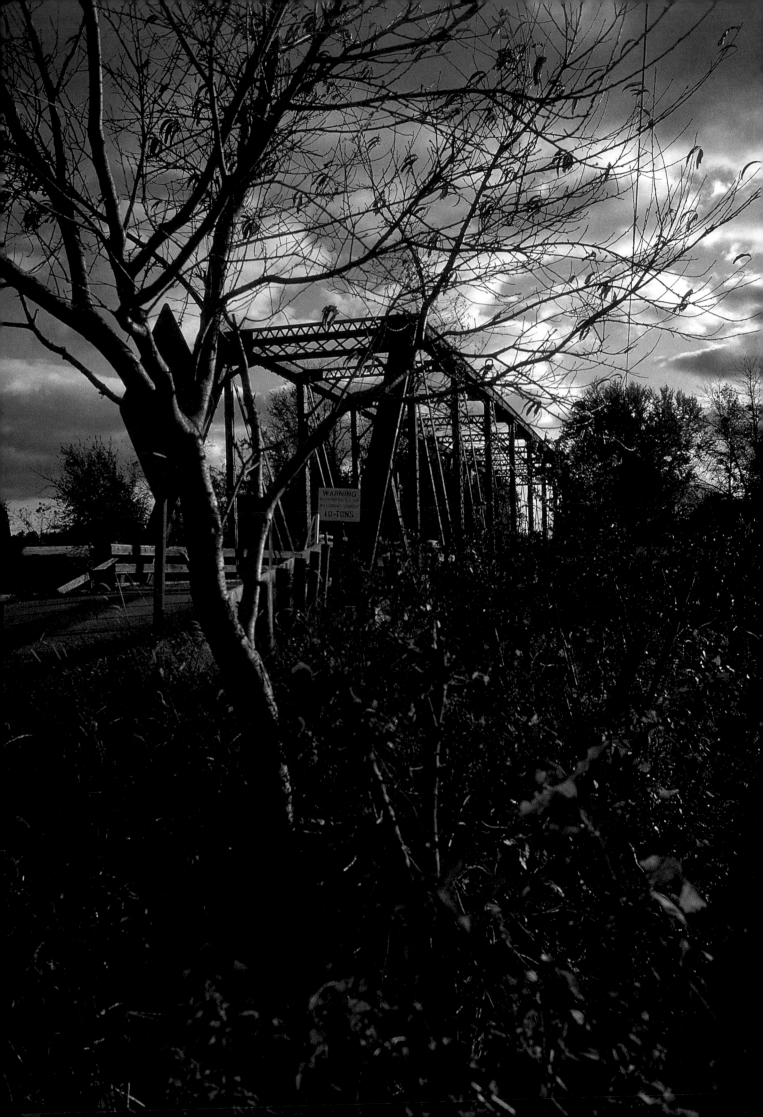

WARNING
10 TONS

Bridge near Sibley. GREG SLEE

Loose Park fountains at sunrise. CHRISTINA MCPHEE

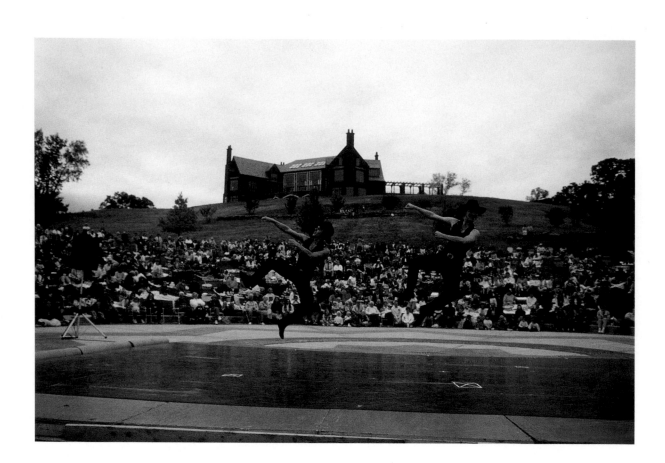

The State Ballet of Missouri performing outdoors. JANIS K. KINCAID

Overleaf: The Tom "Boss" Pendergast House. TERRANCE MCGRAW

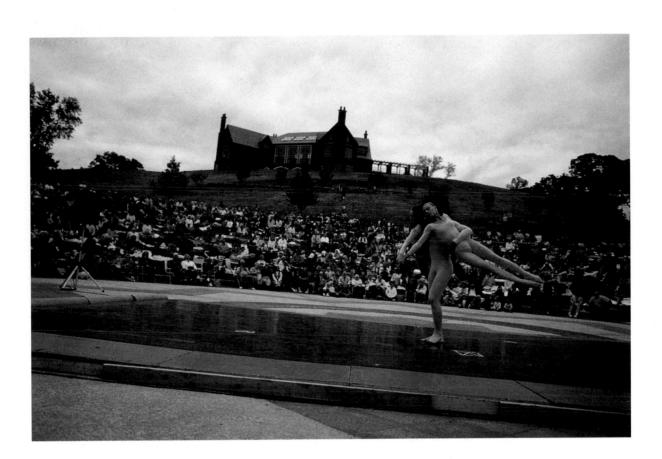

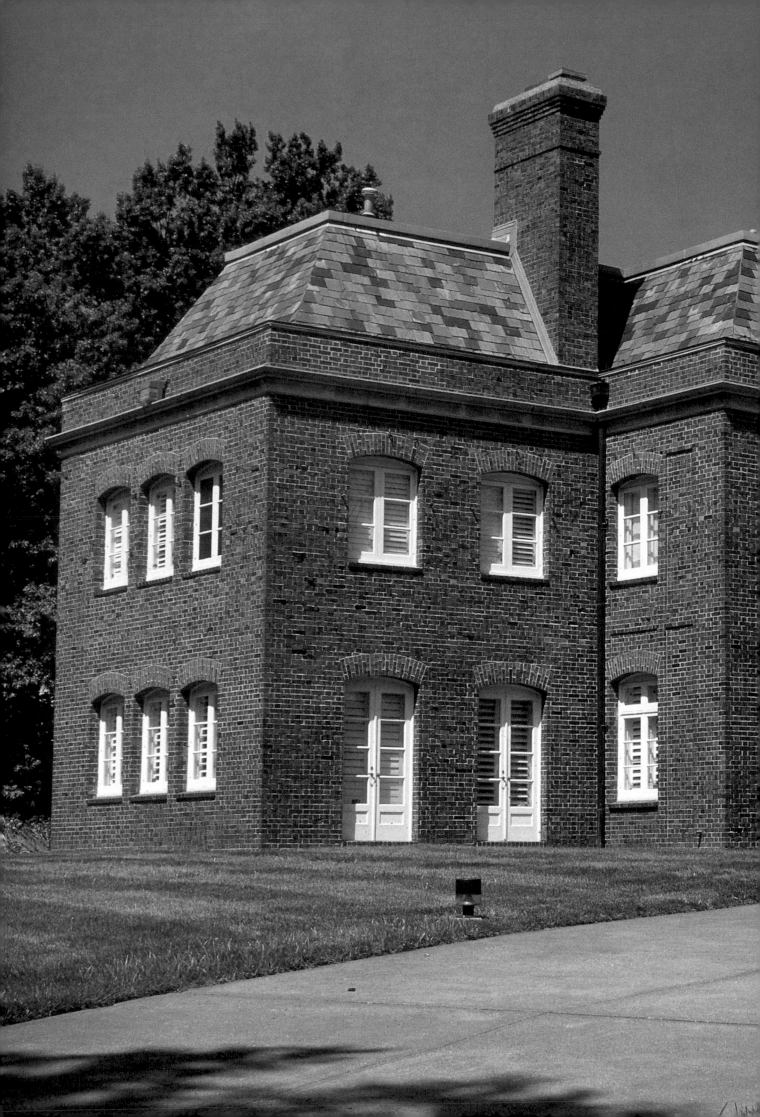

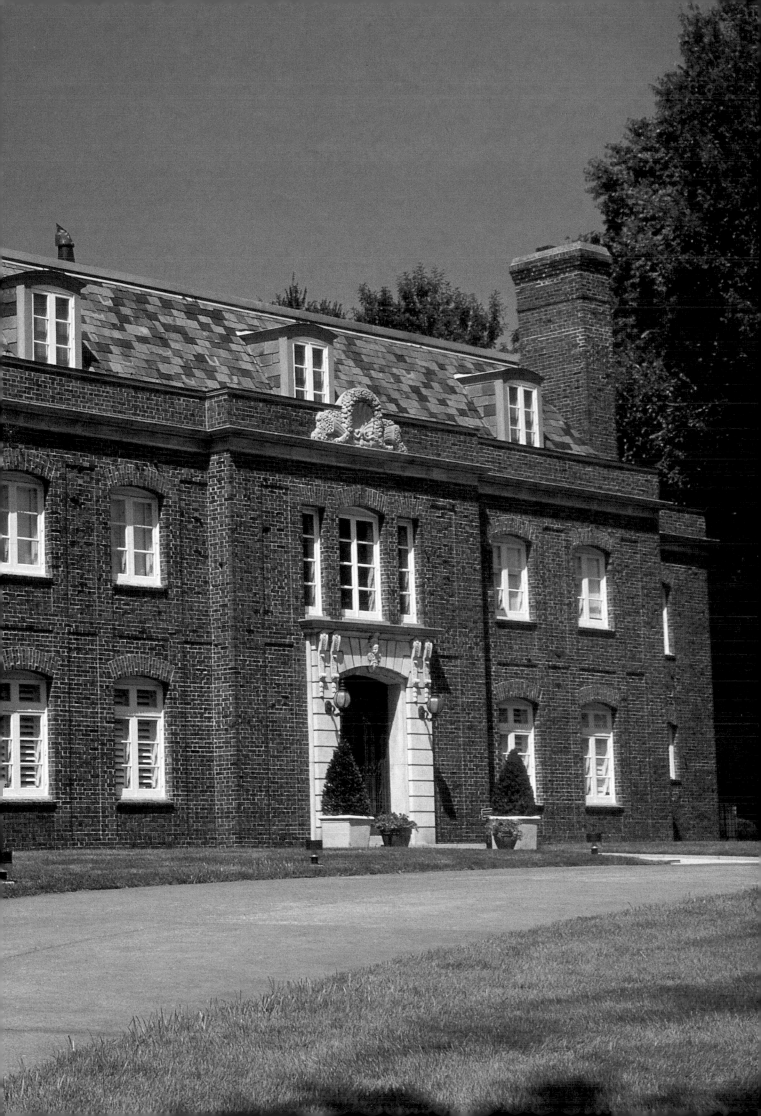

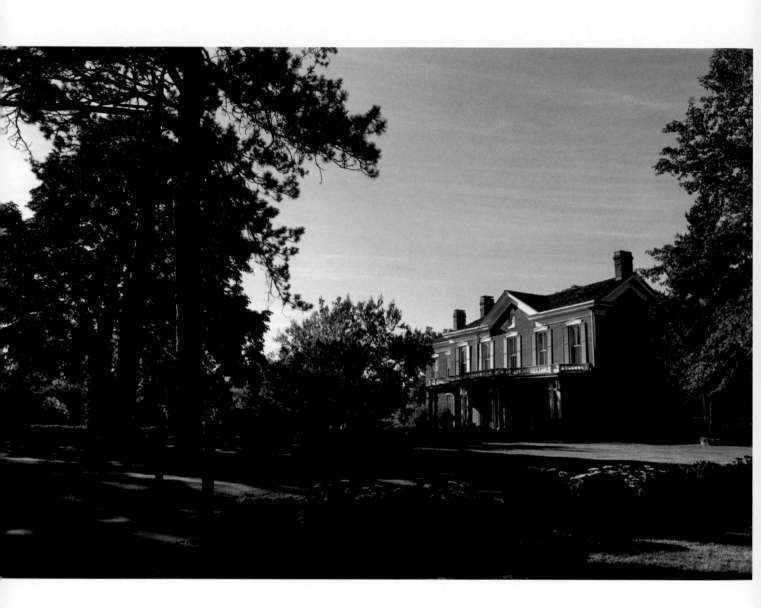

The Seth E. Ward Homestead. CHRISTINA MCPHEE

The Vaile Mansion in Independence. SHELLEY L. DENNIS

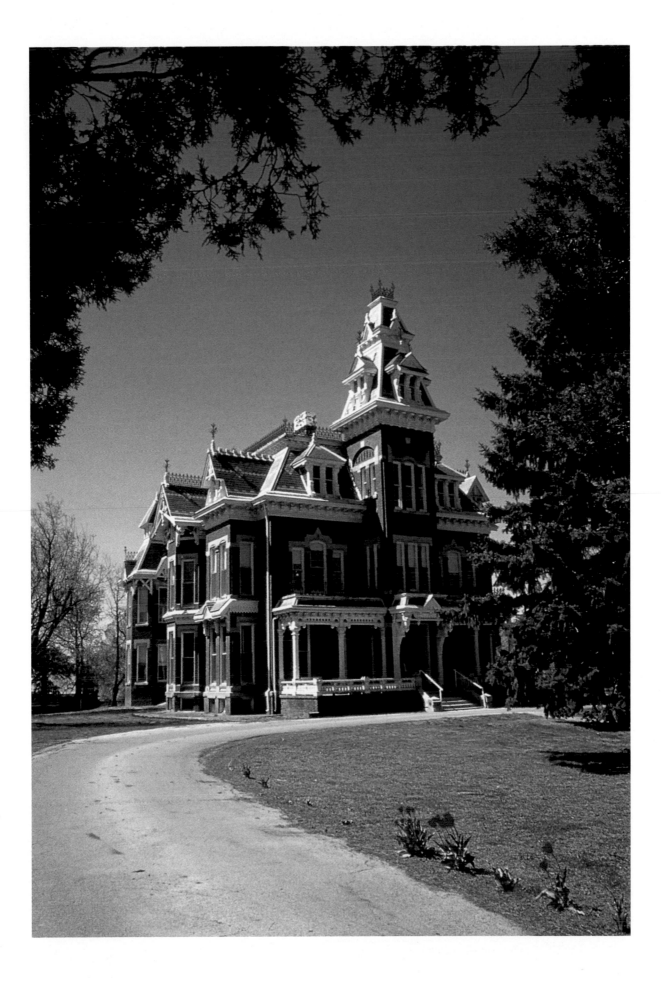

The John Wornall House Museum. TERRANCE MCGRAW

The Truman Home in Independence. SHELLEY L. DENNIS

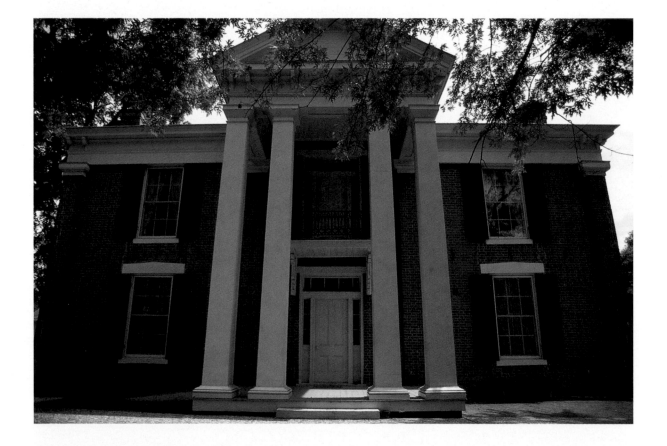

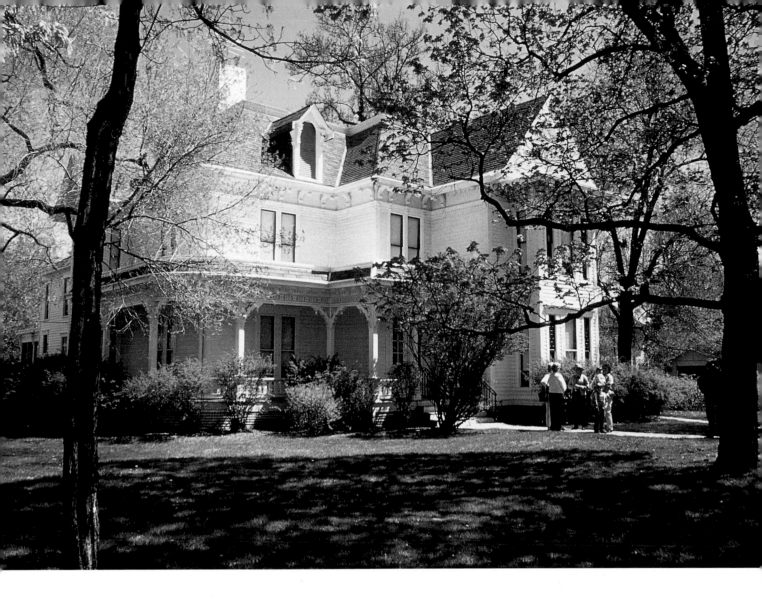

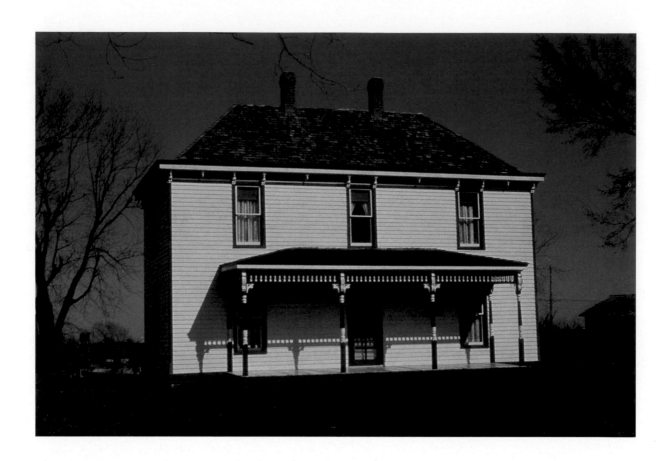

The Truman Farm Home in Grandview. SHELLEY L. DENNIS

Girl and pumpkins. GREG SLEE

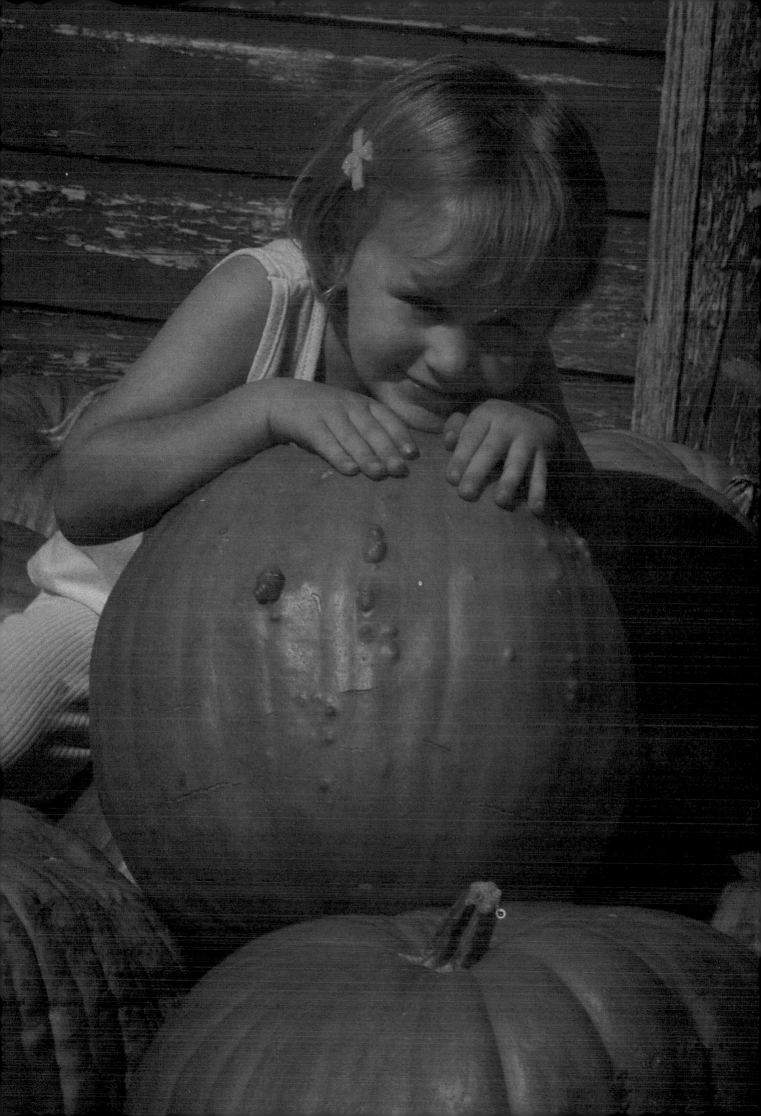

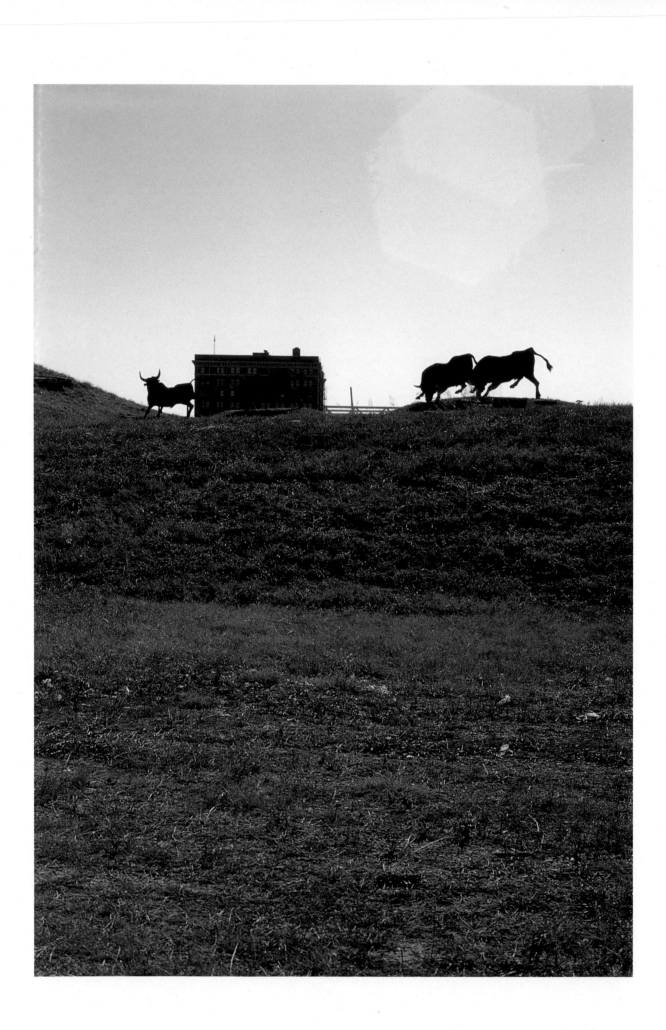

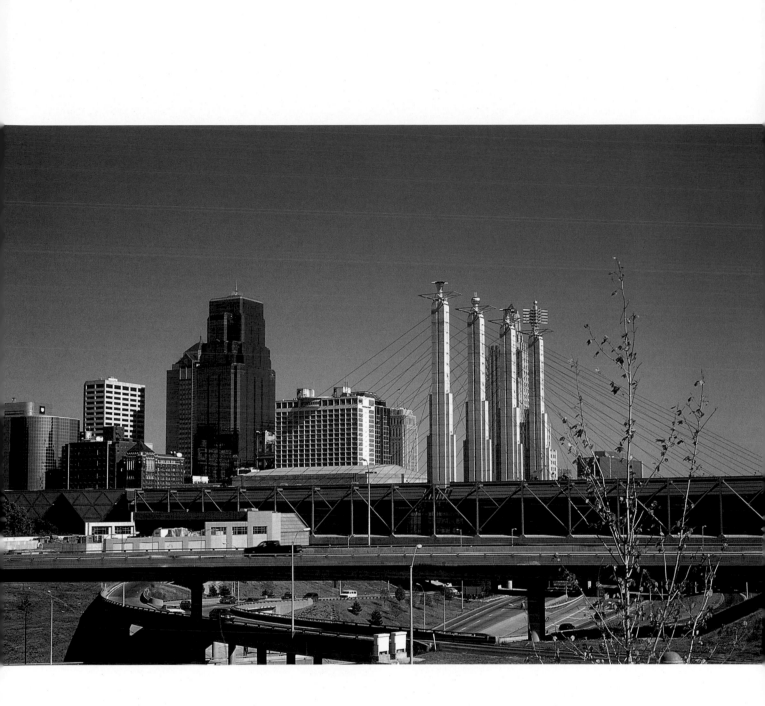

Iron bulls in West Bottoms. JESSICA WITHINGTON (LEFT)
AND CURTIS VANWYE (OVERLEAF)

Downtown. JESSICA WITHINGTON

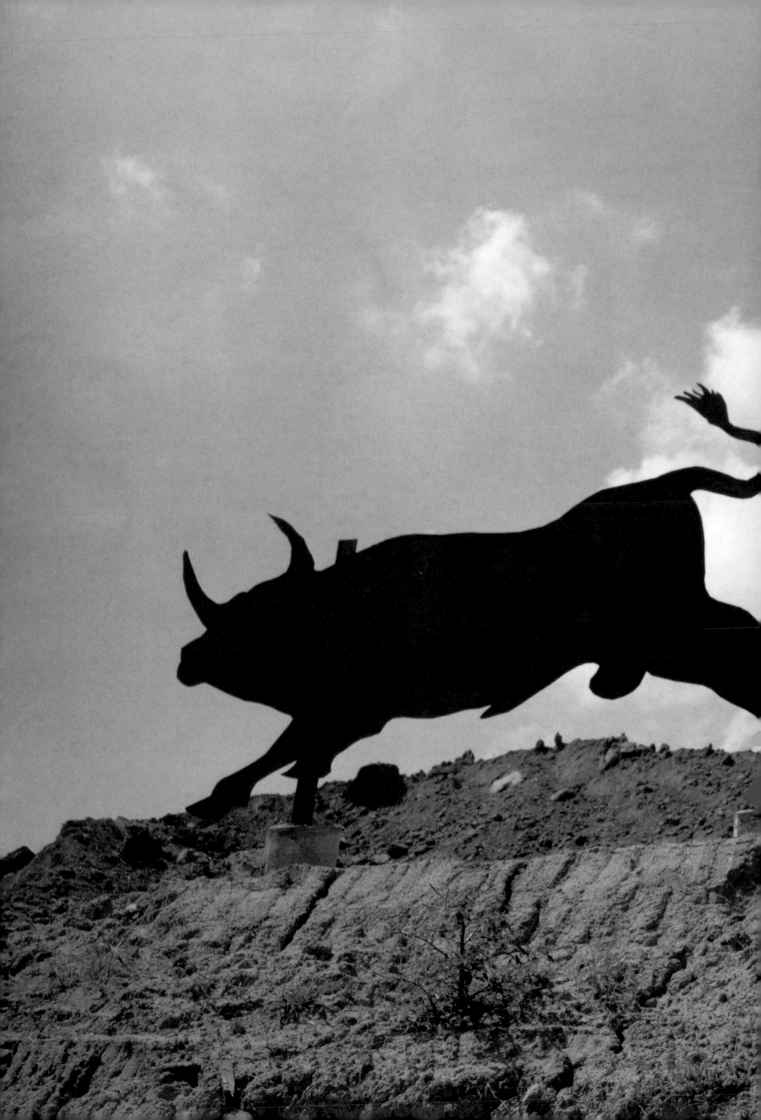

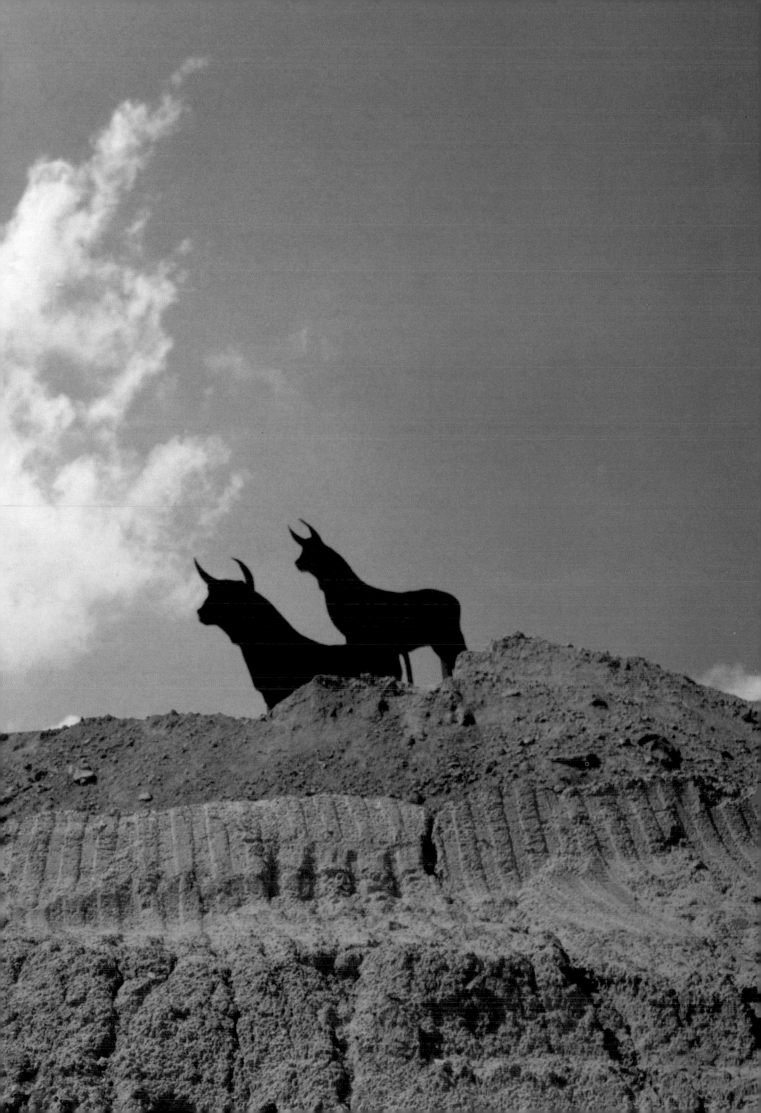

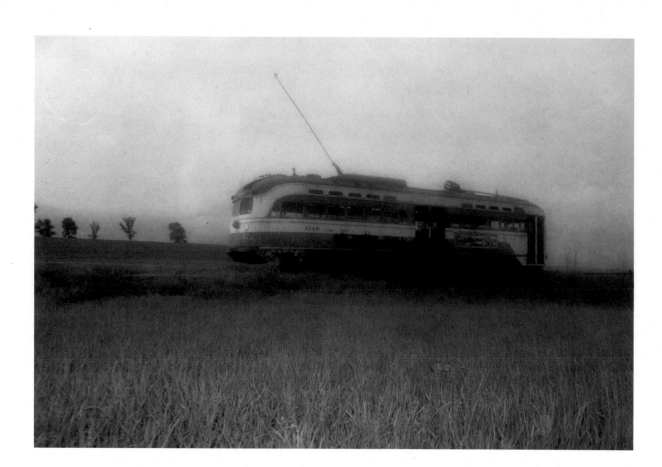

Old trolley car near Belton. MICHAEL ALAN BAILEY

Grain elevators at sunset. WILLIAM HELVEY

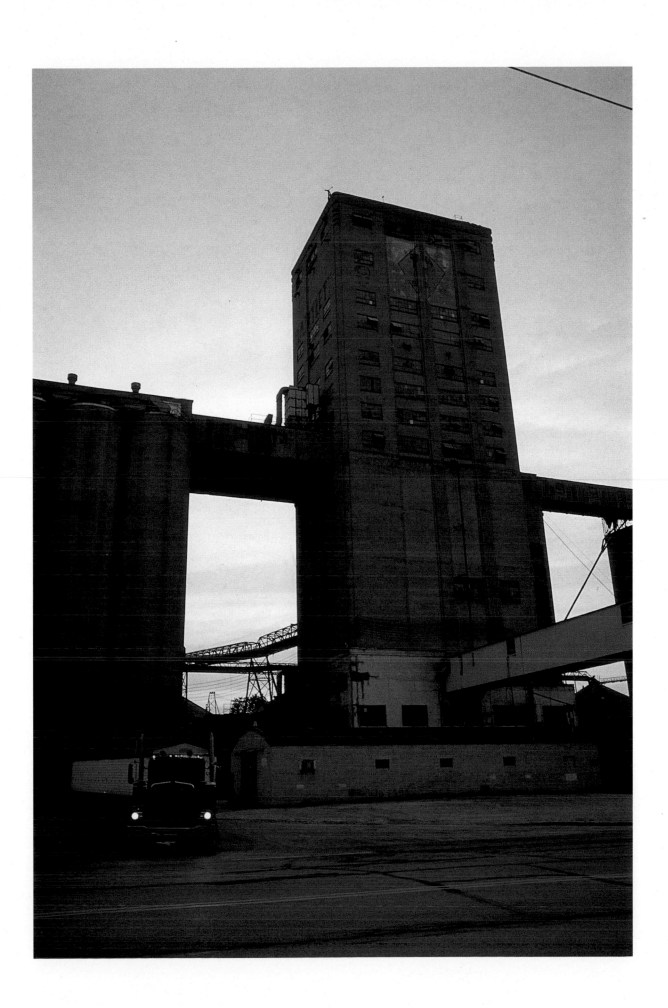

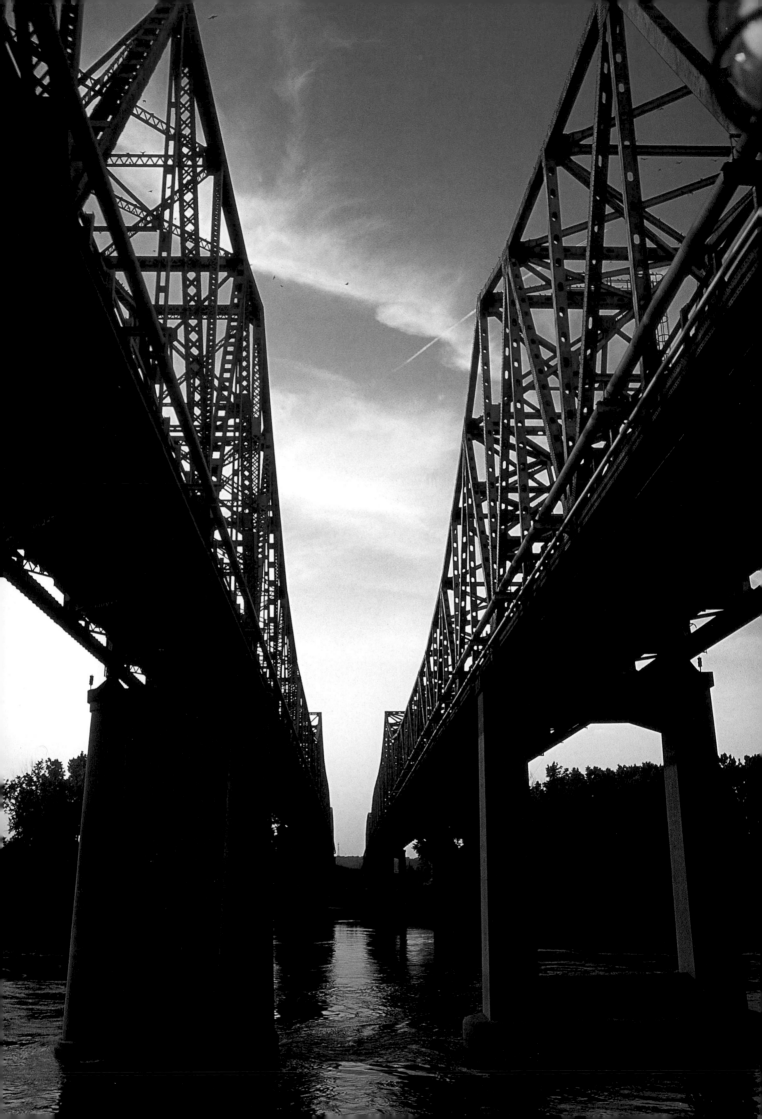

Bridges across the Missouri River. WILLIAM HELVEY

Missouri River Queen paddle wheel. WILLIAM HELVEY

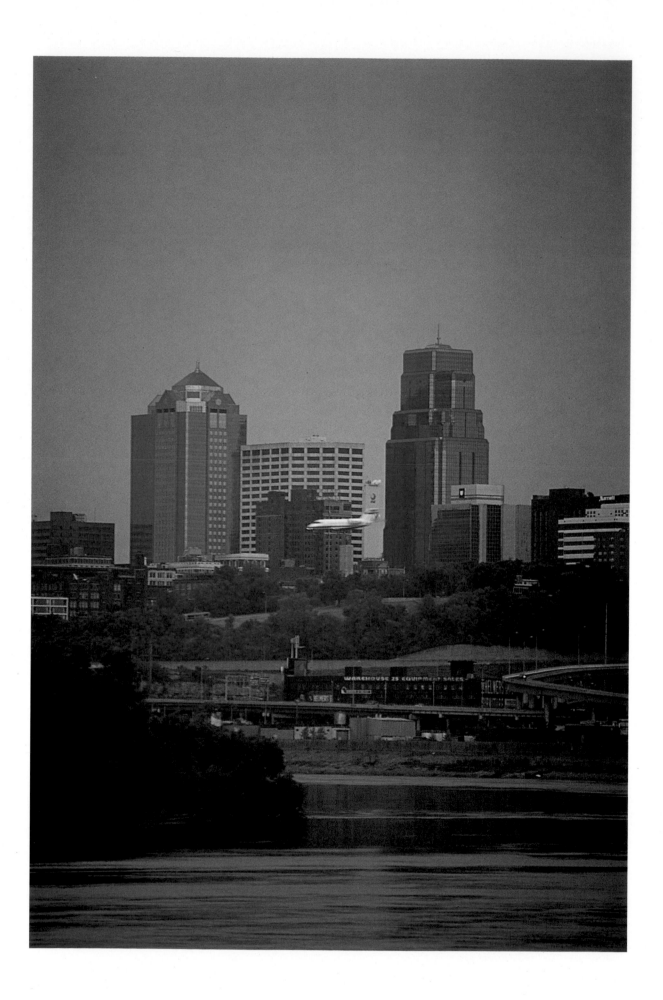

A corporate jet landing at Kansas City Municipal Airport. WILLIAM HELVEY

Bow of the *Missouri River Queen.* WILLIAM HELVEY

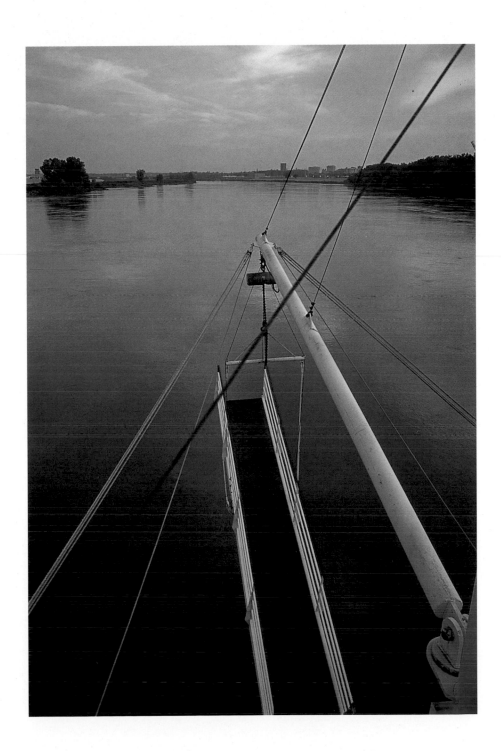

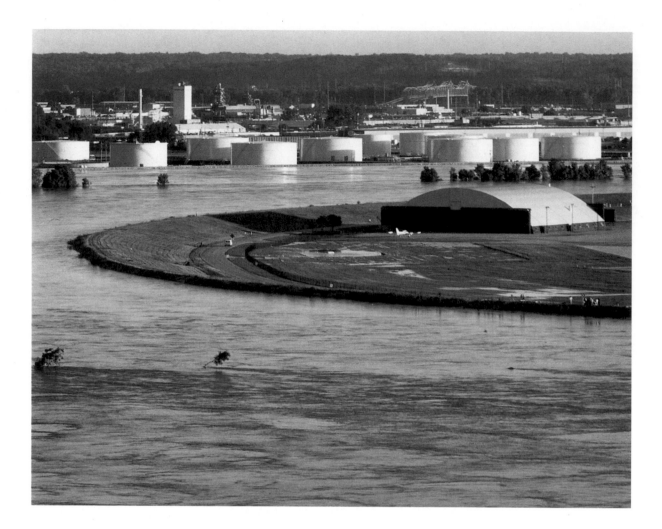

The Missouri River, the morning after the cresting of the flood of 1993. PAT JESAITIS

Every night during the flood hundreds came to see the river skirting the downtown airport. YVONNE O'BRIEN

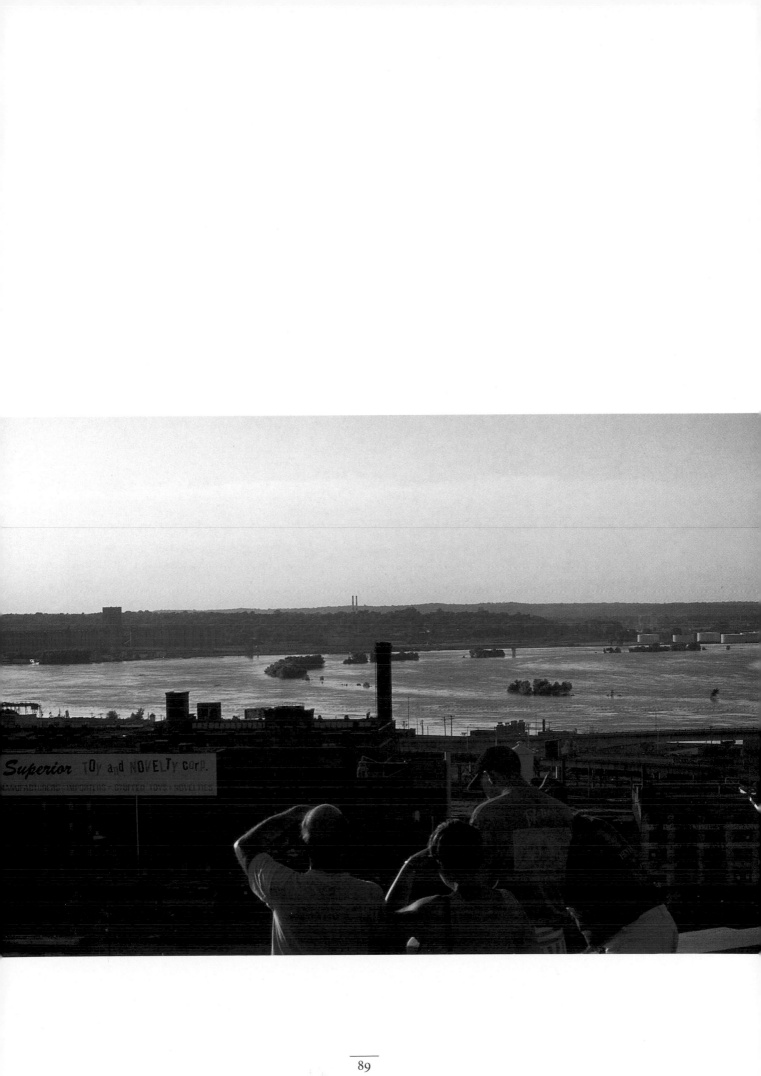

The tower of KCTV, Channel Five. YVONNE O'BRIEN (BELOW) AND
TERRANCE MCGRAW (RIGHT)

Overleaf: Topless building in West Bottoms. CURTIS VANWYE

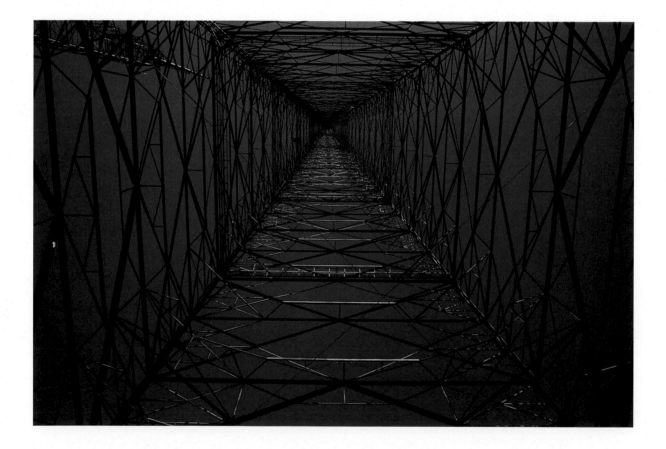

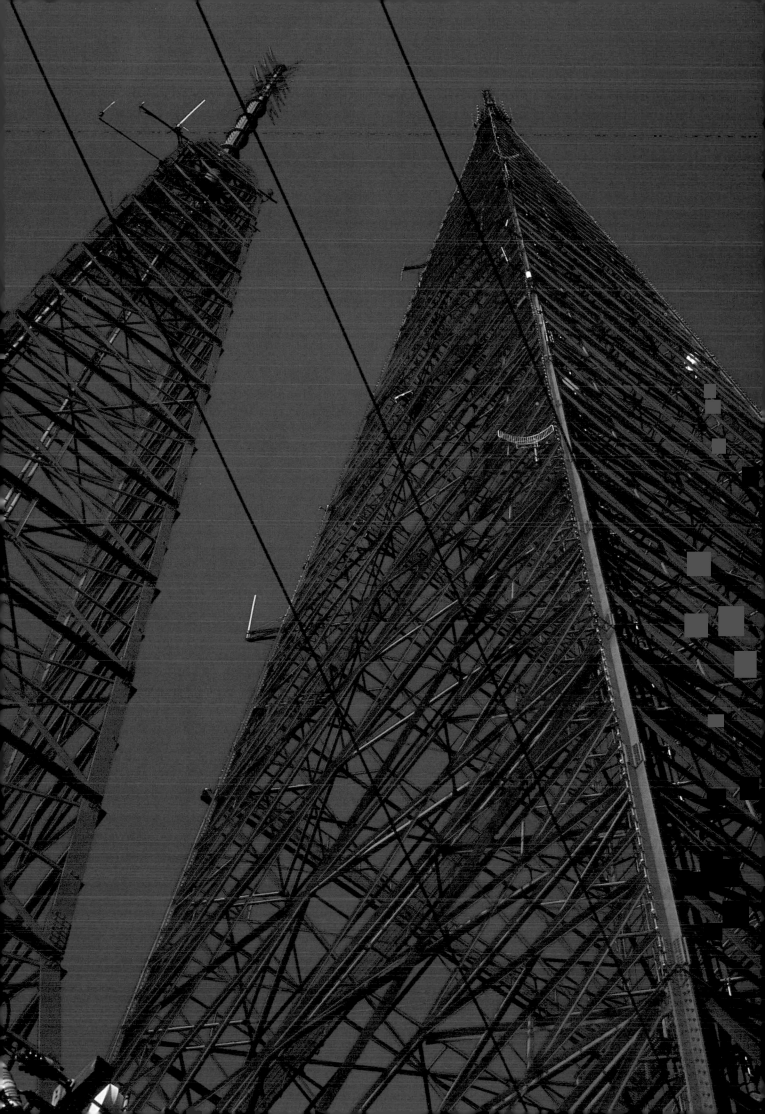

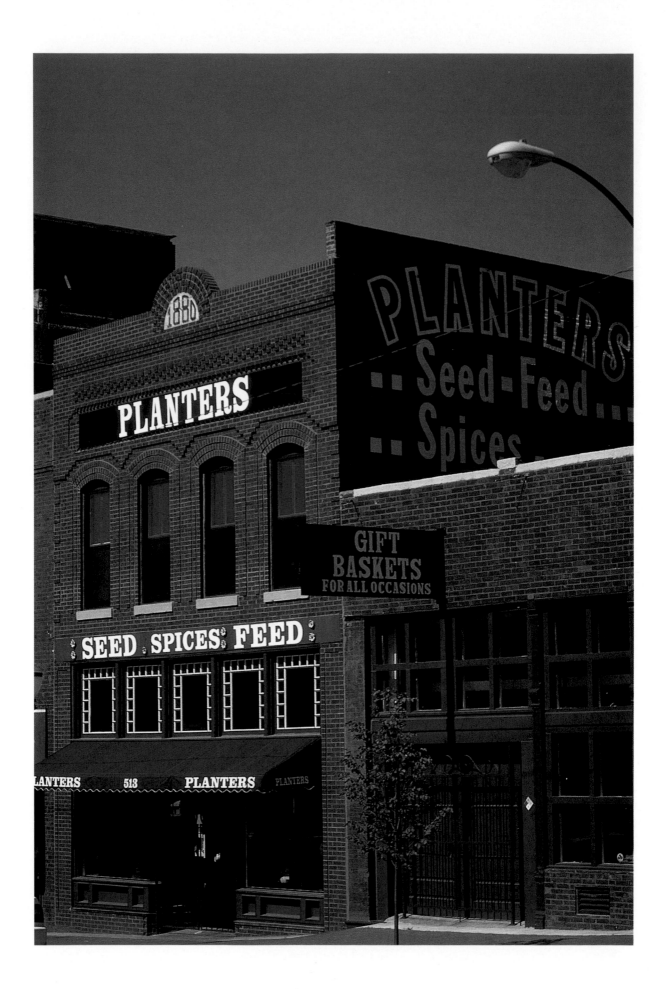

Planters, 509 Walnut, purveyors of feed, seed, and bulk spices since
the turn of the century. HARLAN SMITH

"Stepping Out." CURTIS VANWYE

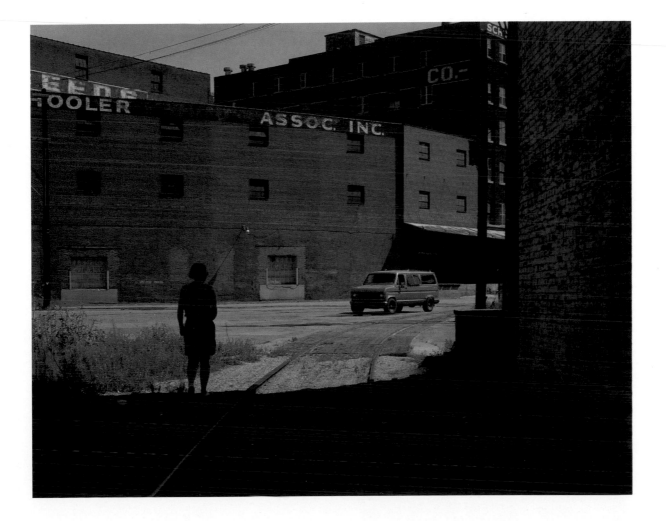

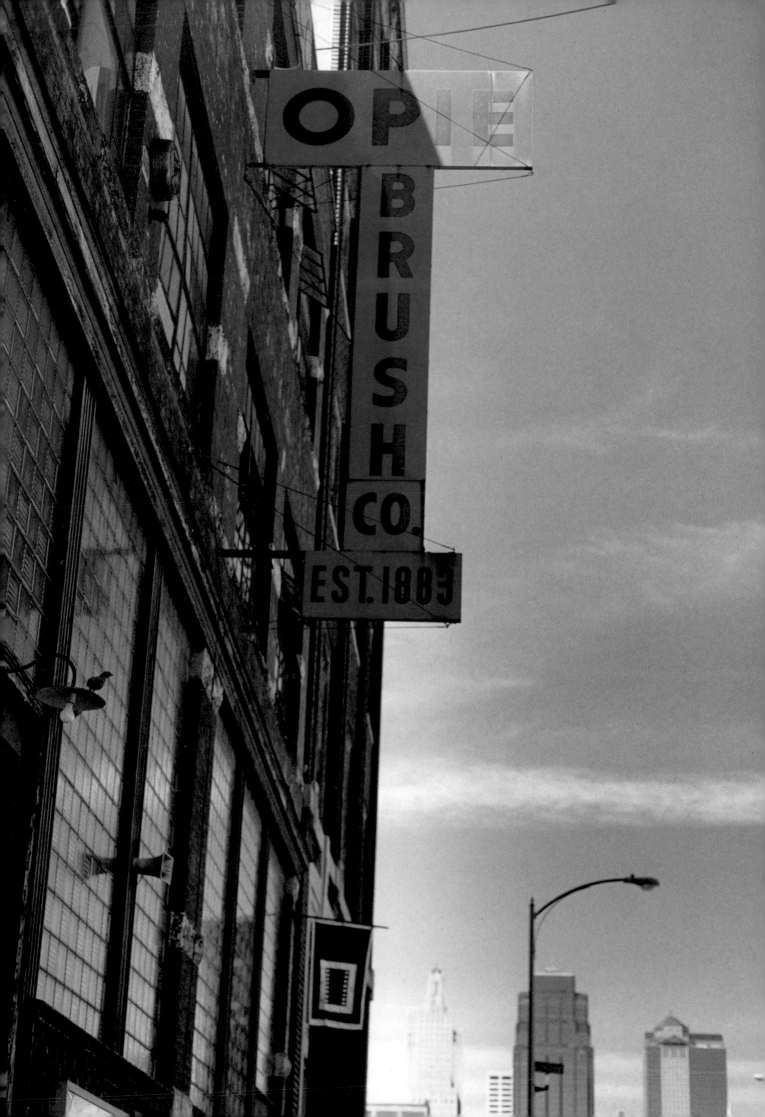

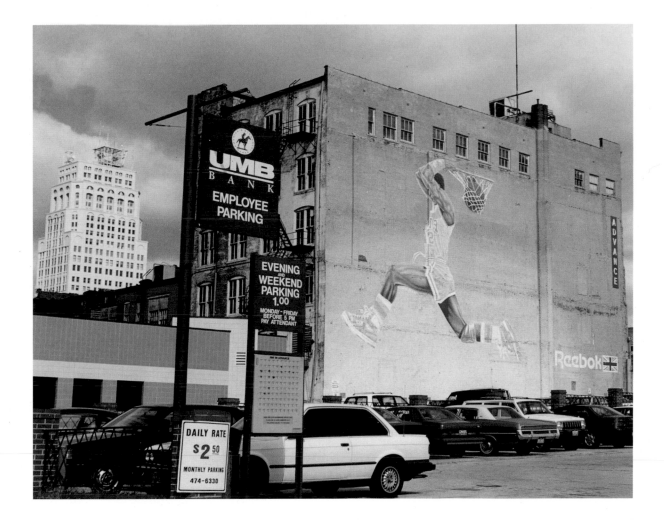

Opie Brush Co. CHRISTINA MCPHEE

Basketball mural, painted in 1988 in conjunction with Kansas City's
hosting of the NCAA Final Four, parking lot at 14th and Grand.
G. ANN (FOX) CHRISTIAN

Christian Church crosses at Country Club Plaza. WILLIAM HELVEY

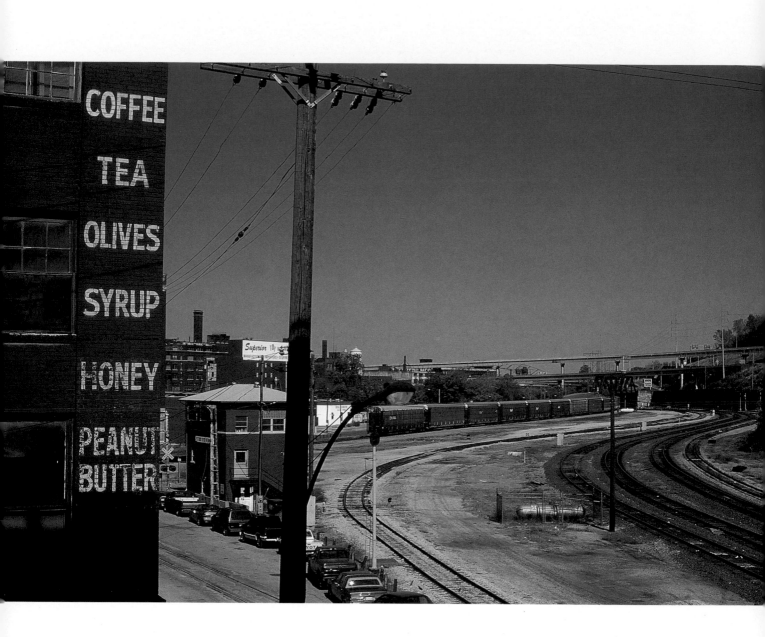

Views of West Bottoms. JESSICA WITHINGTON

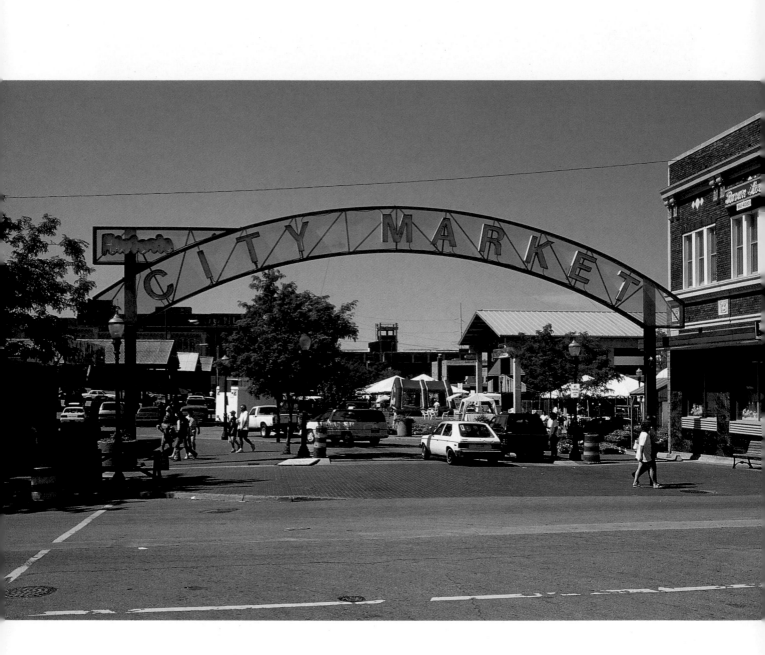

City Market, 5th and Walnut. HARLAN SMITH

A neighborhood vegetable stand, 78th and Wornall Road.
HARLAN SMITH

Bazaar shelves at a fund-raiser for St. George's Serbian
Orthodox Church. LINDA BRUNK SMITH

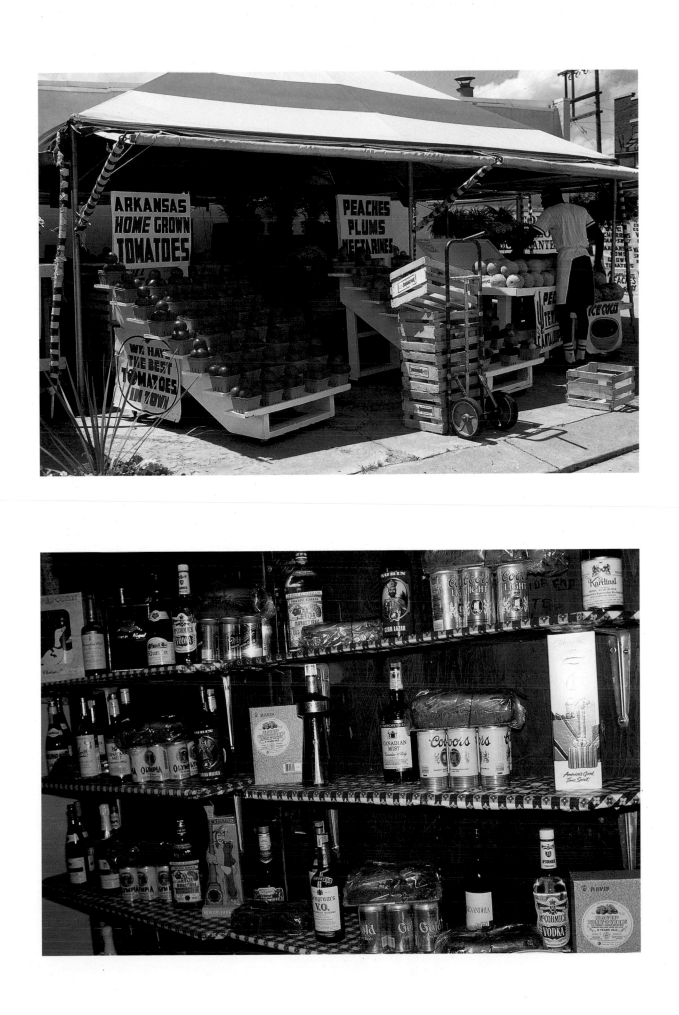

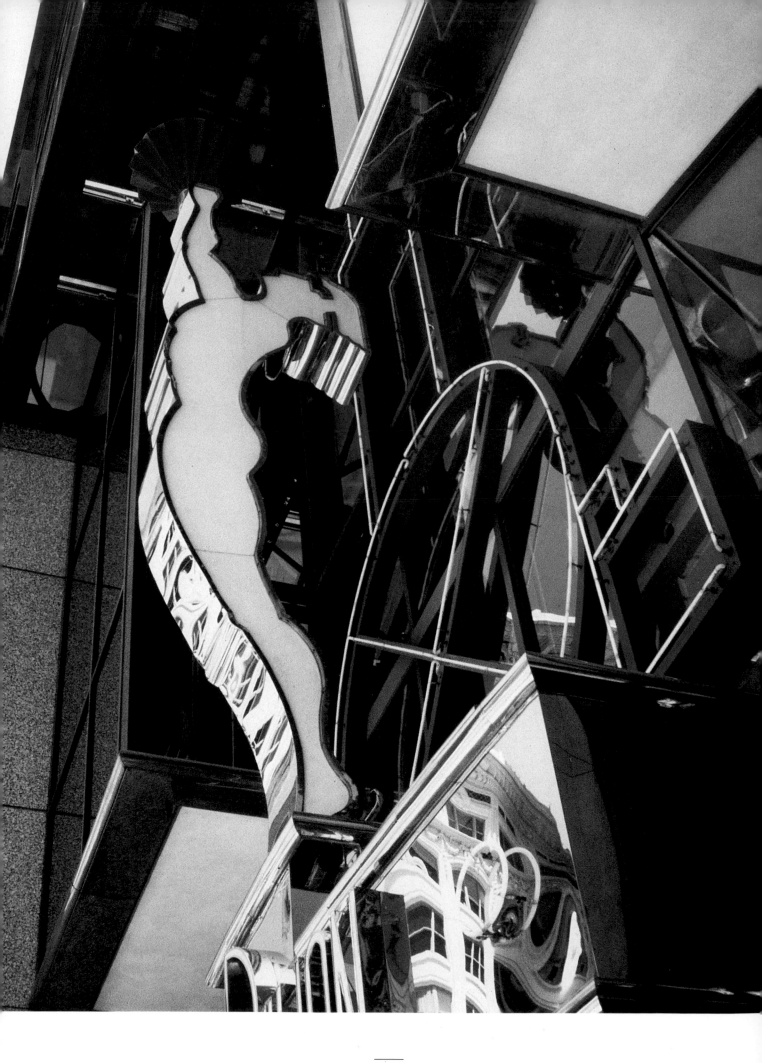

Sculpture over the entrance to AT&T Town Pavilion. PAT JESAITIS

Kemper Arena entrance. CURTIS VANWYE

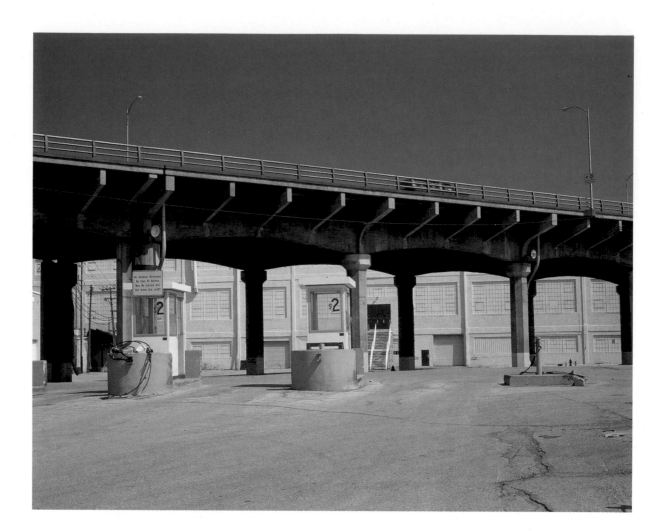

Ticket booths at the American Royal. CURTIS VANWYE

The National Starch plant. PAT JESAITIS

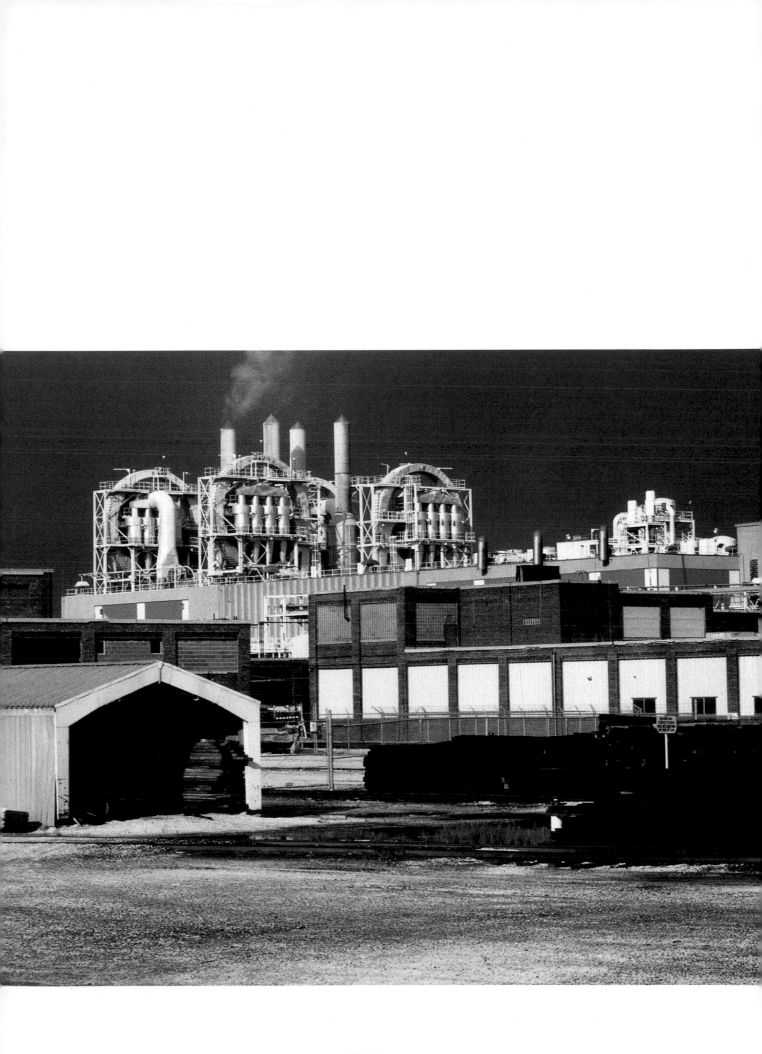

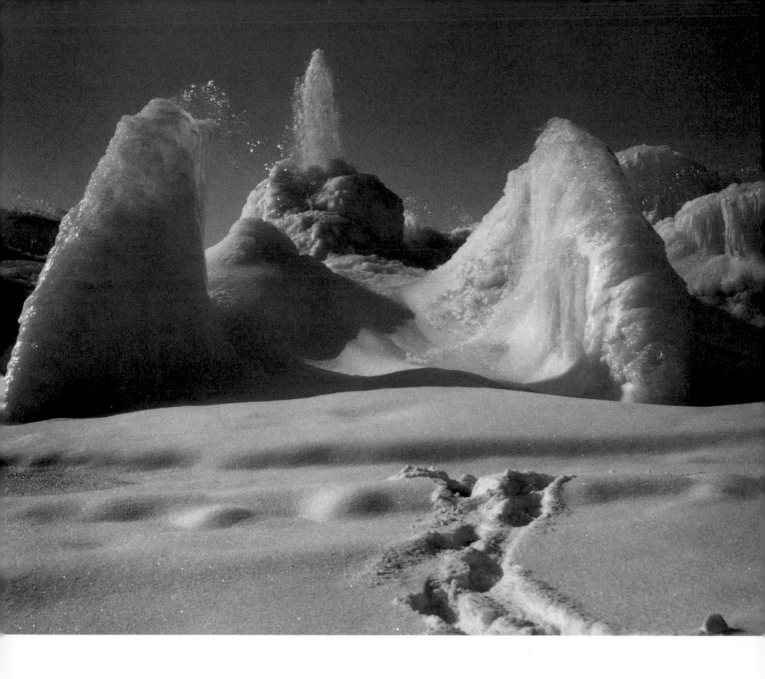

Winter fountain. PAT JESAITIS

Sledding in a Jackson County park. GREG SLEE

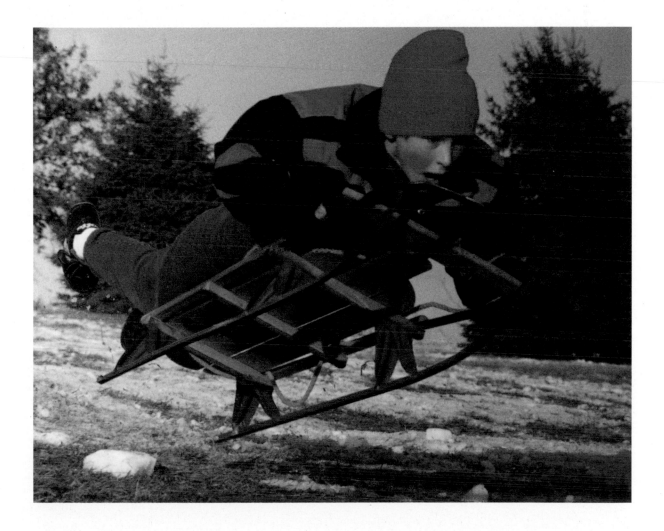

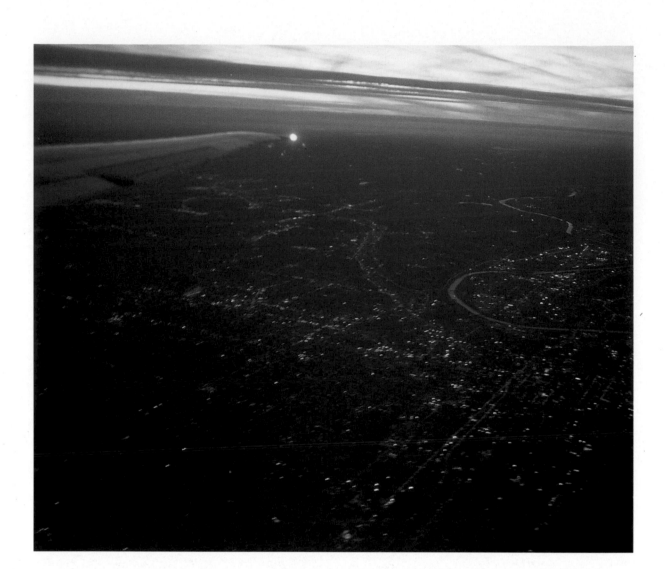

Kansas City from the air. YVONNE O'BRIEN

Northland Cathedral windows. PAT JESAITIS

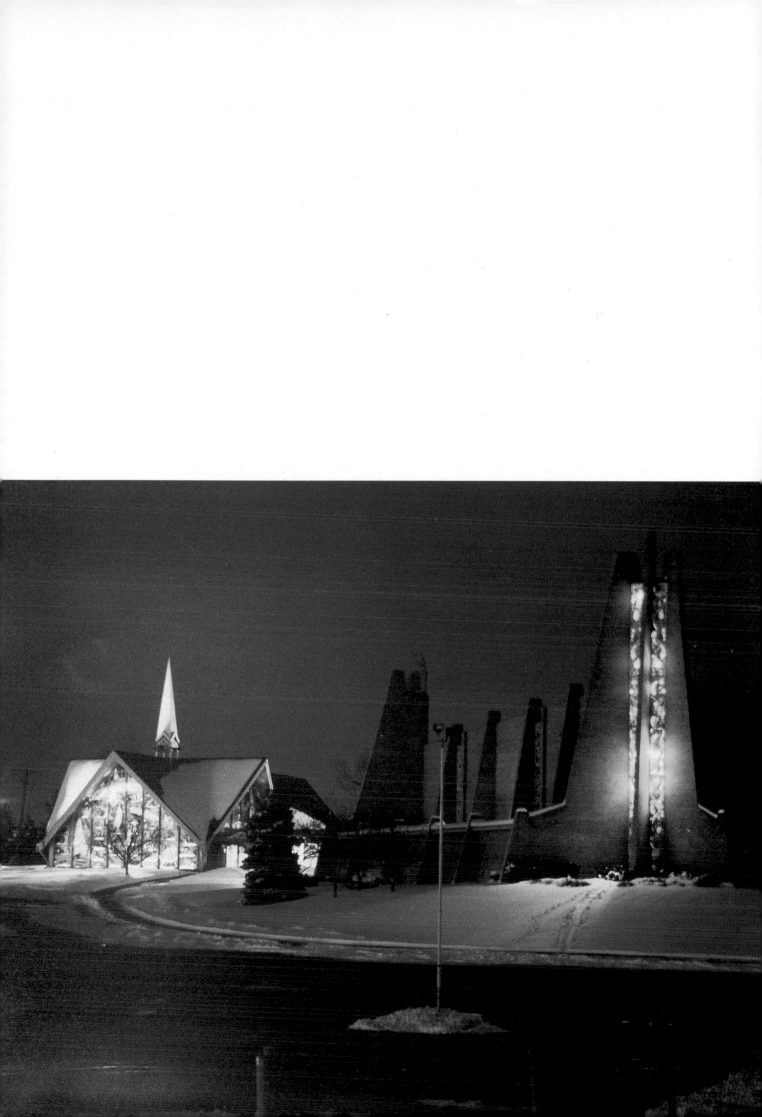

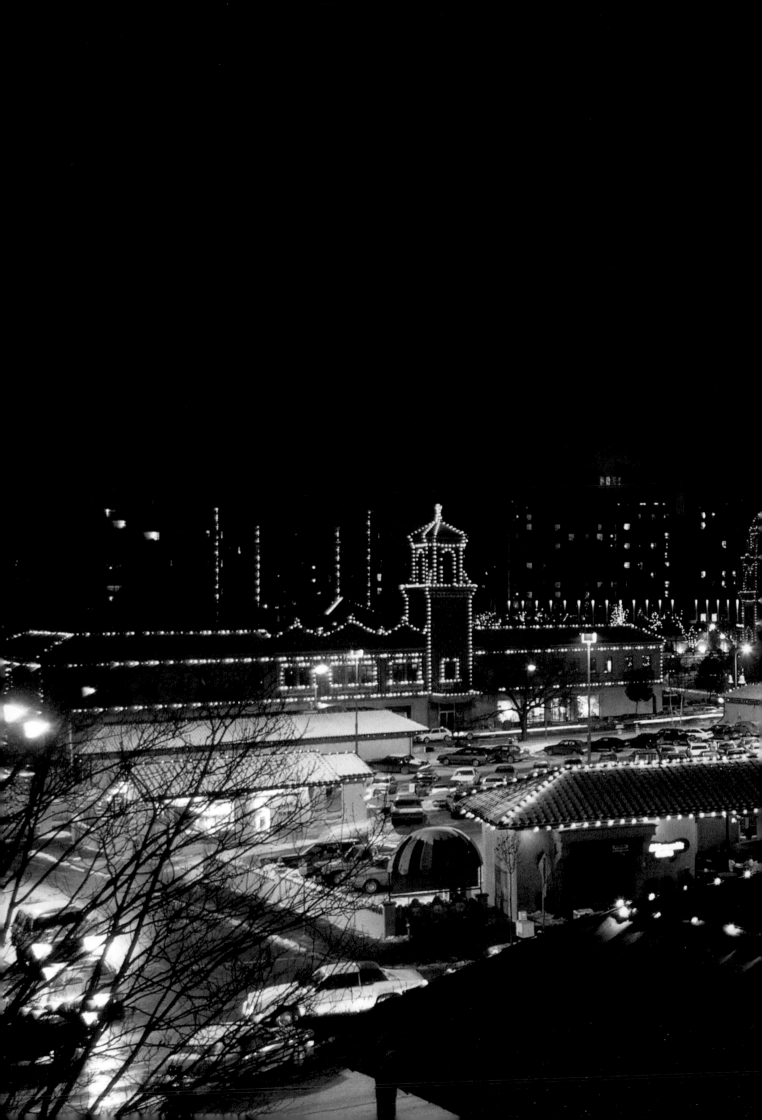

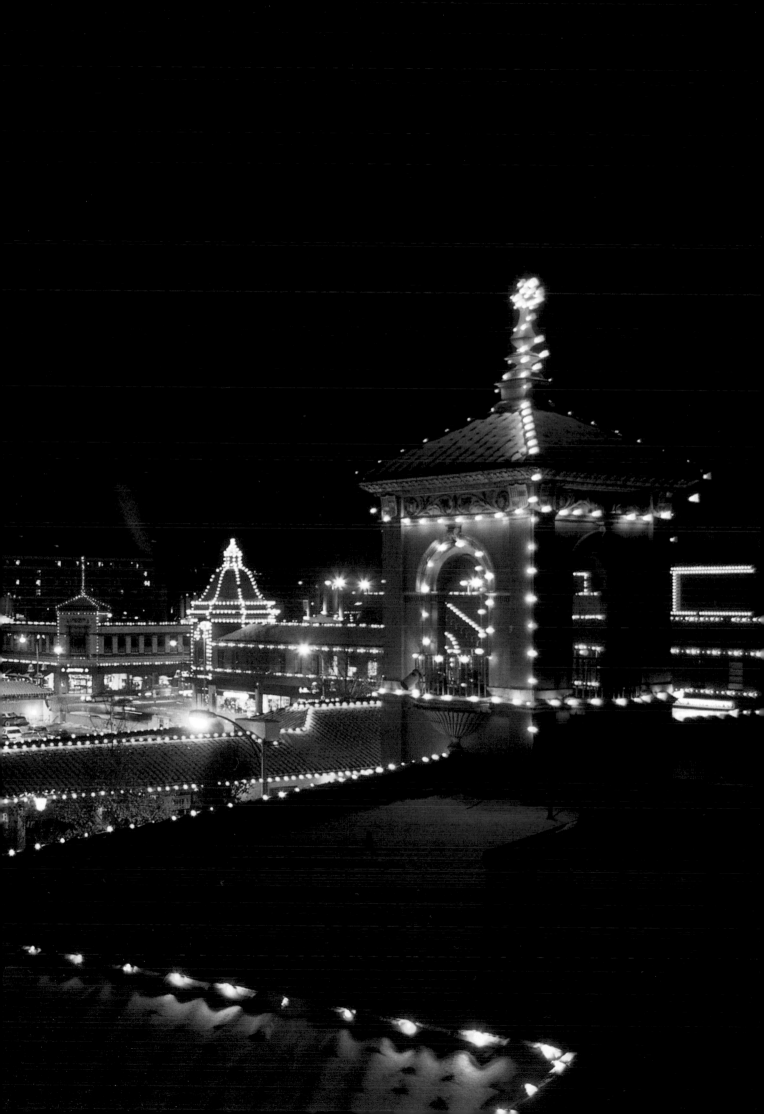

Christmas at the Plaza. BART LARSON
(PRECEDING PAGES AND BELOW) AND
PAUL R. RANDALL (RIGHT AND FAR RIGHT)

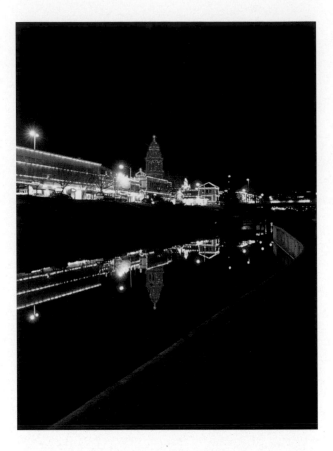

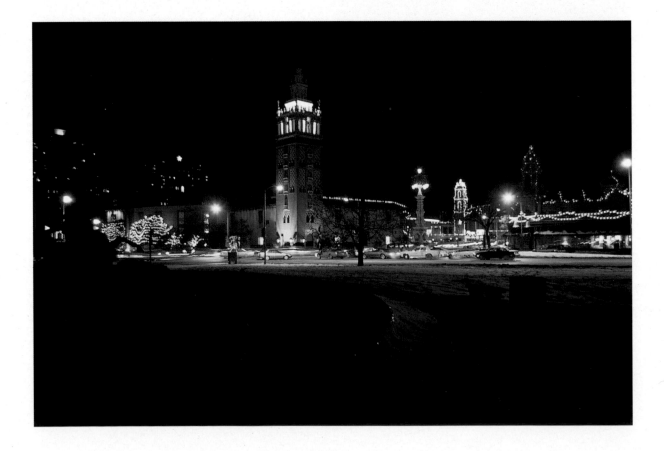

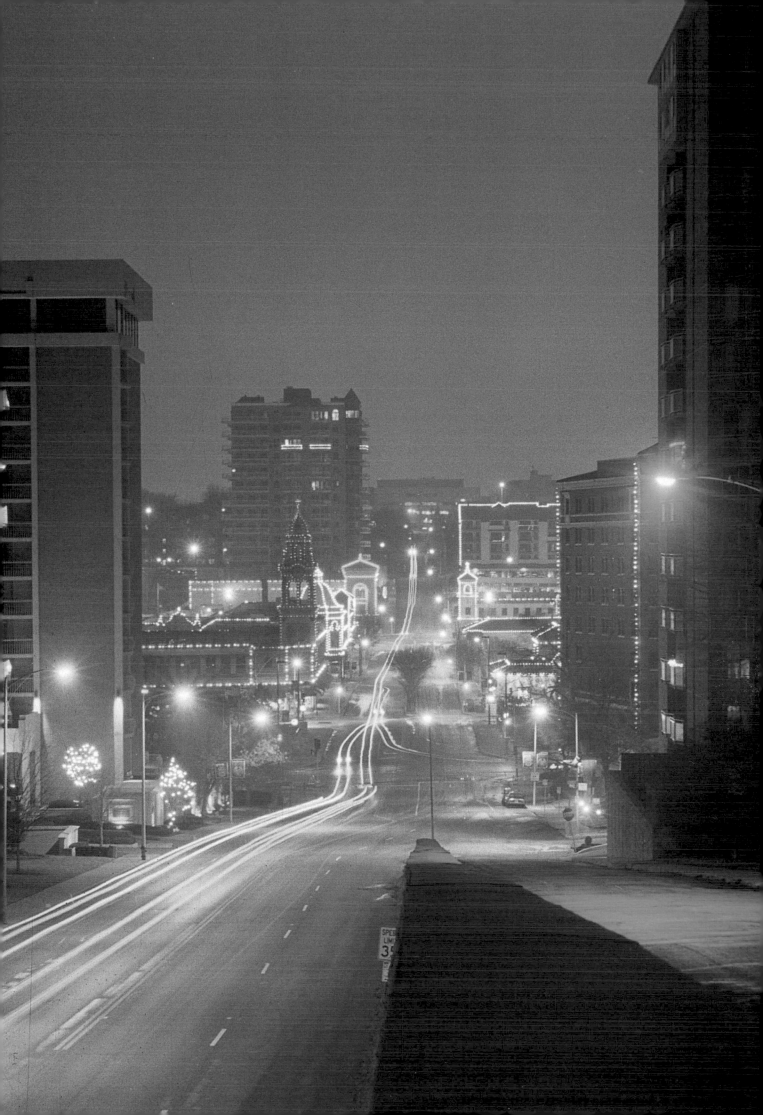

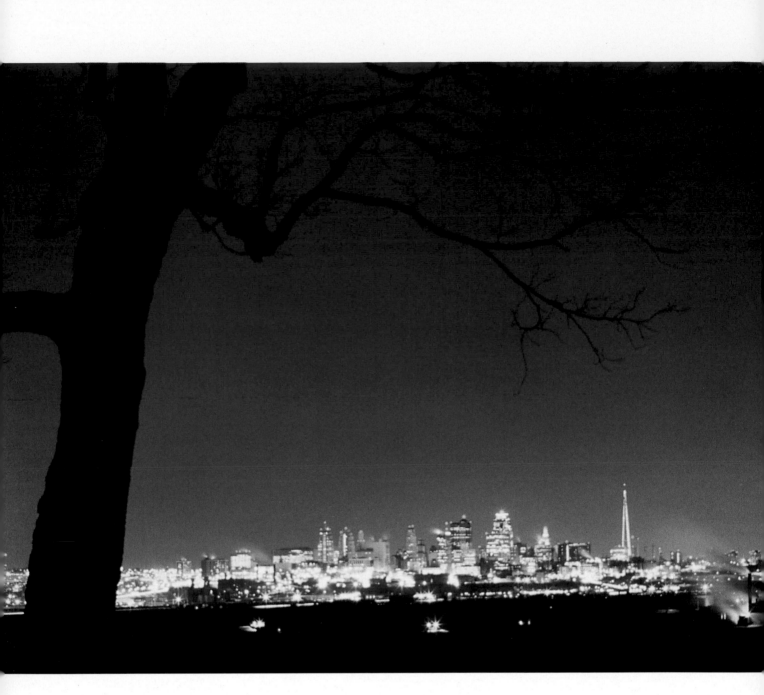

Skyline. PAT JESAITIS

Bartle Hall Convention Center. PAT JESAITIS

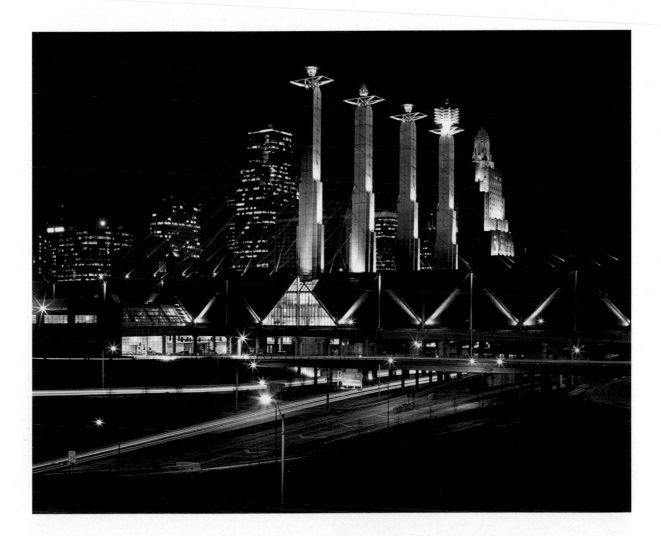

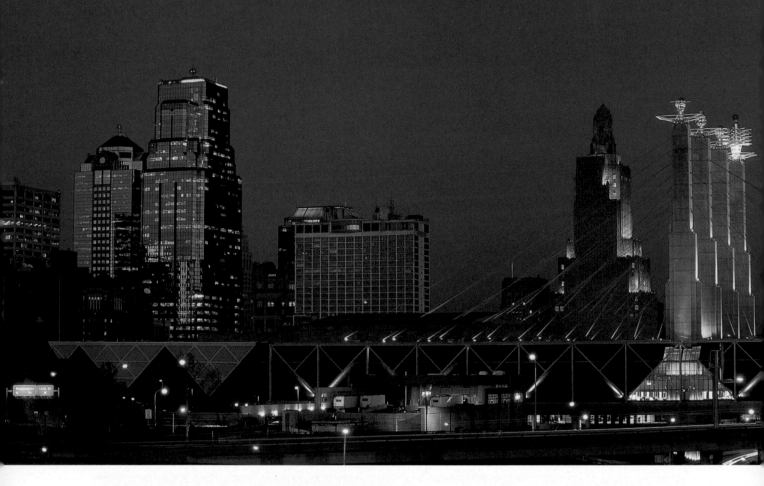

Skyline at sunset. TERRANCE MCGRAW

Power & Light Building at night.
TERRANCE MCGRAW

Detail of Bartle Hall pylons.
TERRANCE MCGRAW

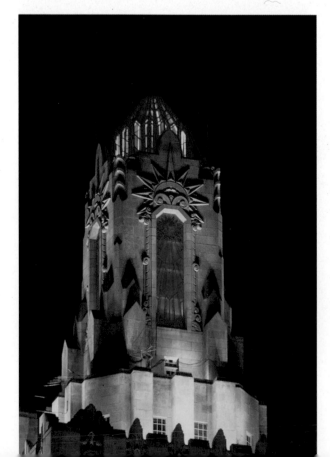

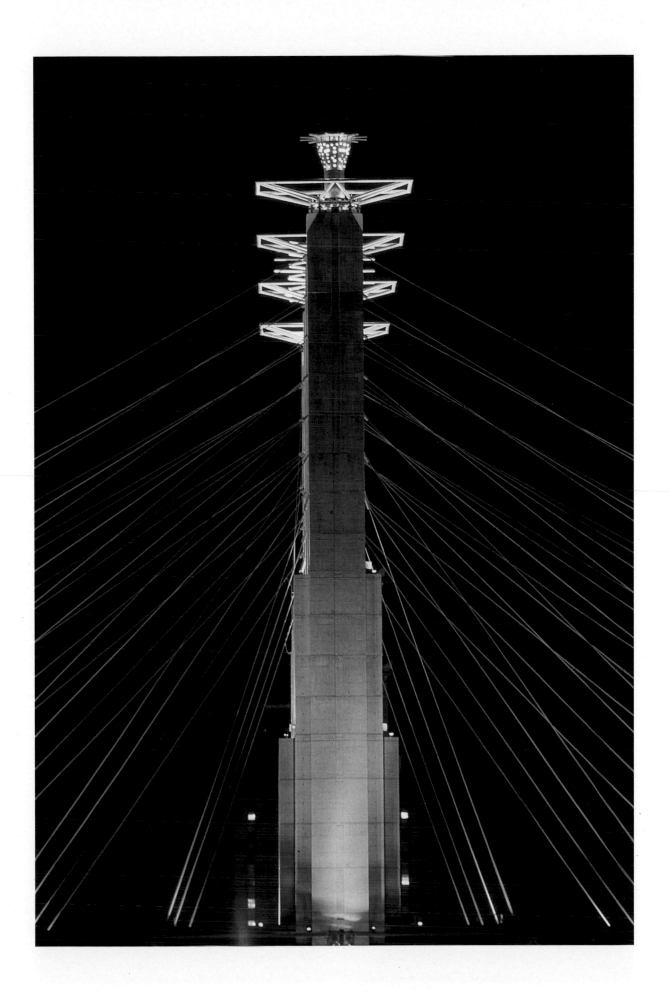

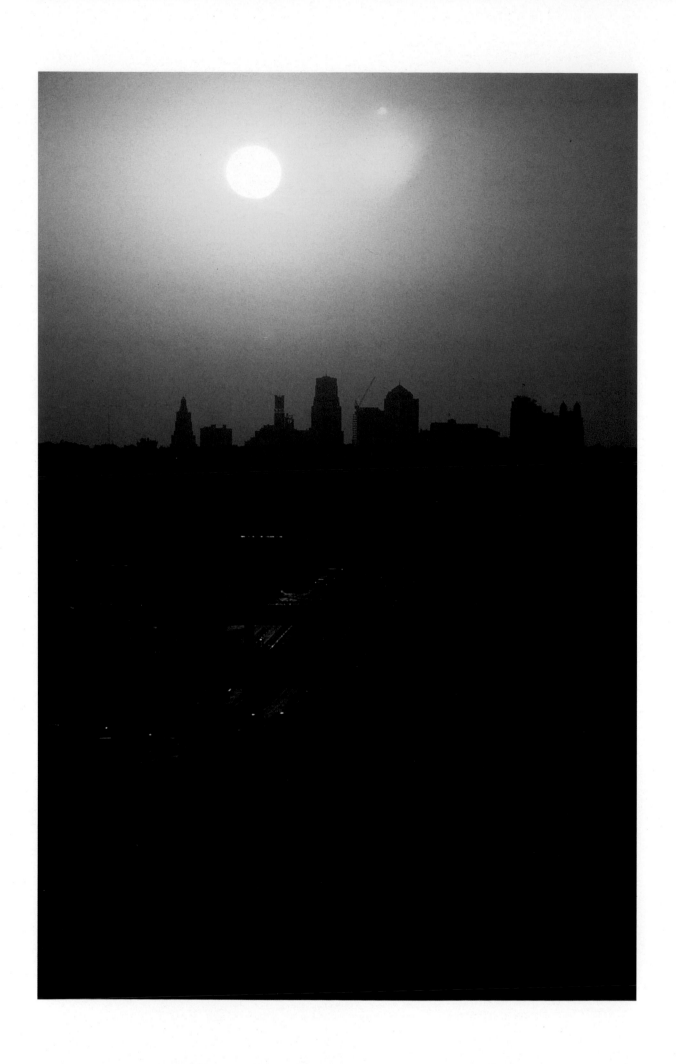

CONTRIBUTING PHOTOGRAPHERS

Michael Alan Bailey (pp. 8, 18, 25, 27, 62, 82) is a freelance photographer and videographer in Kansas City. He is also a registered radiologic diagnostic technologist. His work has been published in *Popular Photography, International Photographer,* and *Kansas City—A 24 Hour Heartland Portrait.* Hallmark Cards has selected one of his prints for a greeting card in its Ambassador Line. He has won numerous awards for his photography, not only in the Kansas City area, but nationally as well. The NBC television network used one of his videos about a local young man on *Eyewitness Video* in 1993. Mr. Bailey also volunteers his photography talents to the American Diabetes Association of Greater Kansas City and the Head Injury Association of Kansas City.

G. Ann (Fox) Christian (p. 97) is the owner of My Eye's on You, a portrait studio she opened in Columbia, Missouri, in 1993. She is a lifelong Missouri resident, and photography has always been a part of her life. Many of her photos have become keepsakes for family and friends. She has created bookmarks, calendars, recipe cards, and greeting cards from many of her travel photos. Although she provides a variety of portrait services, her studio specializes in children's photography. She is a member of the Professional Photographers of America and Wedding and Portrait Photographers International.

Linda H. Cozad (p. 34) is a past president of the Junior League of Kansas City, Missouri. She has also served on the boards of the Greater Kansas City Council on Philanthropy, Missouri Repertory Theatre, and Young Audiences. She pursues photography as a hobby.

Shelley L. Dennis (pp. 13, 14, 40–41, 42, 52, 73, 75, 76) has taught science, English, and physical education at the junior high, high school, and university levels, using her photographs as teaching materials in her classroom. Recently, she has started her own company, The Narrow Way Photography. Specializing in scenic landscapes, she now photographs and markets her own line of inspirational pictures and cards. When she's not traveling, Shelley calls a tent in Leadville, Colorado, home.

William Helvey (pp. ii, 29, 39, 63, 65, 83, 84, 85, 86, 87, 97) has been a photographer, videographer, animator, and artist for more than thirty years. He has received numerous awards and had more than thirty photography exhibits.

Skyline. BART LARSON

119

Favorite subjects have included state and national parks throughout the United States. His photos have been published in *Popular Photography, Camera 35, Missouri Life, Missouri Magazine, Colorful Missouri,* and regularly in publications for University Extension at Lincoln University, where he is employed as a state communications specialist. A member of the Columbia Art League, St. Louis Artists' Guild, and St. Charles Artists' Guild, he exhibits in many shows each year and teaches photography and art classes.

Pat Jesaitis (pp. iv–v, 16–17, 33, 64, 88, 102, 105, 106, 109, 114, 115) specializes in art photography, featuring architecture and city- and townscapes. While he exhibits primarily in the Midwest, his photographs have been in shows around the country, including California, Colorado, Florida, Georgia, Indiana, Montana, New York, Pennsylvania, Texas, Vermont, and Wisconsin. Over the past twelve years his work has been accepted for more than a dozen one- and two-artist shows and he has received more than forty awards. Pat's works are also represented in a number of private collections. He teaches in the Bloch School of Business and Public Administration at the University of Missouri–Kansas City.

Janis K. Kincaid (pp. 45, 68, 69) is a special sections writer and photographer at Townsend Communications Inc., in Kansas City, Missouri. Her photographs have appeared in Missouri and Colorado newspapers and magazines including the *Kansas City Star, Denver Post,* and *Denver Monthly Magazine.* They now appear in Townsend's suburban newspaper group and four-color magazine, *PEAK,* which focuses on life in north Kansas City. She has won Missouri Press Association and Kansas City Press Club awards for her photography. She also has worked at several Missouri and Colorado television stations as a reporter, weather anchor, videographer, and on the assignment desk. She now resides in Excelsior Springs, Missouri, her native home.

Bart Larson (pp. 12, 26, 28, 32, 37, 60–61, 110–11, 112, 118) is a freelance photographer from Columbia, Missouri, who specializes in outdoor scenic photography. He was the photographer/producer for five issues of the *Missouri Calendar,* the University of Missouri's sesquicentennial calendar, *The Great Flood of '93* poster sold by the American Red Cross, and other works. He recently started his own company called Serenity Productions, which will feature his creative photography as well as Christian books and booklets that he has written.

Terrance McGraw (pp. vi, 20, 21, 23, 24, 35, 70–71, 74, 91, 116, 117) has been freelancing in the Midwest for the past seven years. His current work concentrates on architectural photography.

Christina McPhee (pp. 36, 37, 67, 72, 96) is a landscape painter and photographer whose work addresses qualities of time and human presence in landscape. After completing a B.F.A. at the Kansas City Art Institute, she studied with Philip Guston at Boston University. Self-taught in photography, she is a member of the Society for Contemporary Photography, Kansas City, where her work showed in *Dualities* in 1995. Among the public collections owning her work are the Kemper Museum of Contemporary Art and Design, Colorado Springs Fine Art Center–Taylor Museum, Albrecht-Kemper Museum of Art, Hallmark Fine Art Collection, and United Missouri Bank.

William Mills is the author of many books, including two illustrated with his own photographs, *Bears and Men: A Gathering* and *The Arkansas: An American River.*

Teresa Neuner (pp. 30-31) is the president of the Jefferson City, Missouri, Photo Club, in which she has been an active member for nine years. She is the manager of the camera department for Wright Studio and Camera Shop, where she has been employed for thirty-one years. Her

photographs have appeared in various magazines and several calendars, including the 1995 Union Electric calendar. Her entry into the Canon U.S.A. Photo Contest for National Parks and Forests was a winner. Her favorite work is nature and macro photography.

Yvonne Ellsworth O'Brien (pp. 5, 7, 9, 15, 19, 53, 89, 90, 108, 122) specializes in photographing Kansas City architecture, and her images of the Kansas City skyline have appeared on posters and murals. Her work has appeared in regional and national juried shows, including the Kansas City Arts Coalition River Market show, the Art Research Center's 1994 European tour, and *Current Works*. She has received numerous awards and has been published in *Studio Photography*, *National Historic Foundation*, *St. Louis Magazine*, and the *Kansas City Star*. Education director of a county museum, she is working on a book on Kansas historic forts.

Paul R. Randall (pp. 11, 58, 112, 113) is a Columbia, Missouri, photographer and writer who has recently embarked on three years of travel, starting in Colorado. He first showed his work professionally in 1995 at Columbia's Art in the Park. He works only in pure images—unstaged and without darkroom manipulation, specializing in high-grain films that capture fine detail and enlarge extremely well. He sells his work strictly on a limited-edition basis. Inquiries may be directed to 1248 W. 71st Terrace, Kansas City, MO 64114.

Greg Slee (pp. 13, 56, 66, 77, 107), creative designer for Tension Envelope Corporation, has won numerous graphic design and illustration awards both locally and internationally. His interest in photography began as a hobby, recording his travels (through all fifty states) and gathering source material for paintings and illustrations. Now his photographs have received recognition on their own. Both his paintings and his photographs have been honored with blue ribbons at the Missouri State Fair, and his photographs were published in

Colorful Missouri. He has a special interest in the bluffs, farmland, people, and history of the Missouri River valley.

Harlan Smith (pp. 4, 20, 43, 46, 47, 57, 59, 94, 100, 101) is an active amateur photographer. He is a member of the Kansas City Color Slide Club, where he has twice won the trophy for best nature slide. He has previously been published in *Colorful Missouri* and, along with his wife, Linda, has pictures on permanent display in the Social Security Regional Training Center in Kansas City. The Smiths enjoy wildlife photography, and they travel to zoos and aquariums in the United States and abroad in pursuit of this interest.

Linda Brunk Smith (pp. 22, 45, 48, 49, 101) works with her husband, Harlan, in all of her photographic pursuits. Both are active members of the Kansas City Color Slide Club, where they have won numerous prizes. She had a photograph in *Images of St. Louis* and has pictures on permanent display in the Social Security Regional Training Center in Kansas City. Animal photography is a main interest; with her husband she has visited Africa twice and over twenty zoos in the United States and Europe.

Curtis VanWye (pp. 6, 10, 80–81, 92–93, 95, 103, 104), of Rocheport, Missouri, is an advertising photographer for A. B. Chance Company in Centralia, Missouri. His personal photographs have been displayed in several group shows throughout the Midwest. He has also had a one-person show of his photographs at Stephens College in Columbia, Missouri. Curtis attended Northeast Missouri State University in his hometown of Kirksville. One of his photographs was published in *Colorful Missouri*.

Chris Vleisides (pp. 50–51) is a native of Kansas City, Missouri. He has been in business since 1972, doing commercial photography with a studio in downtown Kansas City. He has also been the Royals' photographer since 1972.

Tim Williams (p. i) is a painter living in Columbia, Missouri. He has traveled extensively, recently returning from three months in Japan.

Jessica Withington (pp. iii, 38, 44, 78, 79, 98, 99) is a student artist at the Kansas City Art Institute. Since she started working with photography, she has consistently dealt with the concept of portraiture in a variety of mixed photo-graphic media. She attended the University of Missouri–Columbia before transferring to the Kansas City Art Institute's photography and video department. She will graduate in the fall of 1996 and plans to further her education and art at the graduate level.

Hank Young (pp. 54, 55) is a professional photographer living in Kansas City.

Kansas City, Missouri, from Kansas City, Kansas. YVONNE O'BRIEN

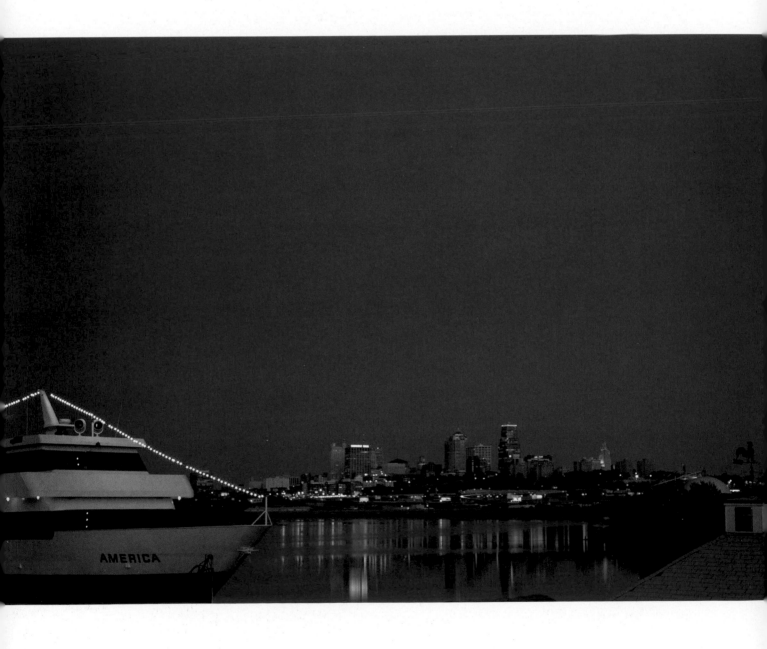